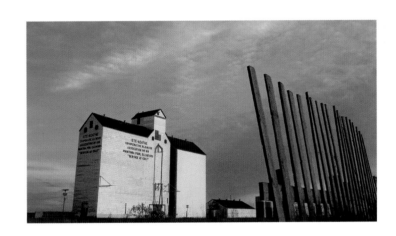

THE
PRAIRIES

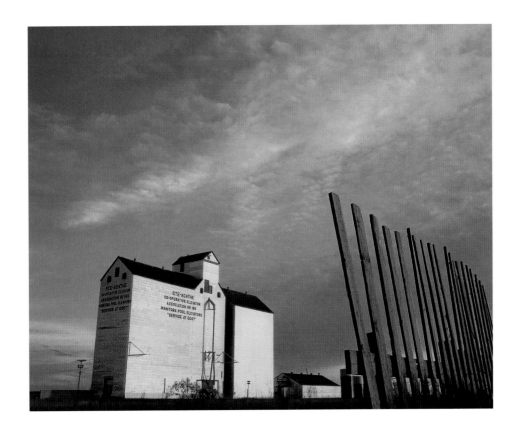

WHITECAP BOOKS
VANCOUVER / TORONTO

Cover and book design by Steve Penner
Cover photograph by Dave Reede / First Light
Text by Tanya Lloyd
Edited by Elaine Jones
Proofread by Lisa Collins
Photo editing by Pat Crowe

Printed and bound in Canada by Friesens, Altona, Manitoba.

Canadian Cataloguing in Publication Data
Lloyd, Tanya, 1973-
 The Prairies

ISBN 1-55110-522-5

 1. Prairie Provinces--Pictorial works. I. Title. II. Series:
Lloyd, Tanya, 1973-
FC3234.2.L66 1997 971.2'03'0222 C96-910741-2

The publisher acknowledges the support of the Canada Council and the
Cultural Services Branch of the Government of British Columbia in making
this publication possible.

**For more information on this series and other Whitecap
Books titles, visit our web site at www.whitecap.ca.**

Canada's prairies, sometimes characterized as endless fields of grain and grasslands, conceal some amazing surprises. Seemingly flat land suddenly reveals a buffalo jump or river canyon; a picturesque church hides a controversial history; a Viking statue stands on the shore of a Manitoba lake. These unexpected twists give an intriguing glimpse into Canada's past and make the prairies a fascinating place to explore today.

The land is the first to yield surprises. In the scenic grounds of Manitoba's Birds Hill Provincial Park, archaeologists have discovered the bones of mammoths that roamed here during the last ice age. In Alberta, scientists continue to unearth fossils of more than 30 dinosaur species in Dinosaur Provincial Park.

The animals that roam the plains today are just as interesting as those that lived in prehistoric times. In Churchill, Manitoba, polar bears gather each fall, waiting for the ice to freeze on Hudson Bay. Saskatchewan boasts the largest land mammal in North America—the bison. And the small burrowing owl can be spotted not in the trees, but on the ground, nesting in the abandoned burrows of mammals.

The prairies also have their share of intriguing characters, from outlaw Butch Cassidy to explorer Samuel Hearne. One of the region's best-known eccentrics is Grey Owl. Famous for his role in conservation and the protection of the beaver, Grey Owl was thought to be a native man until his death. The discovery that he was Archibald Stansfeld Belaney, born in England, caused public uproar.

The photographs in The Prairies encompass vital parts of Canadian history, from Louis Riel's 1885 rebellion at Batoche to the reminders of the first Mennonite and Icelandic settlements. These photographs also celebrate the continued growth of the prairie provinces and their modern role as a centre of Canadian culture and agriculture.

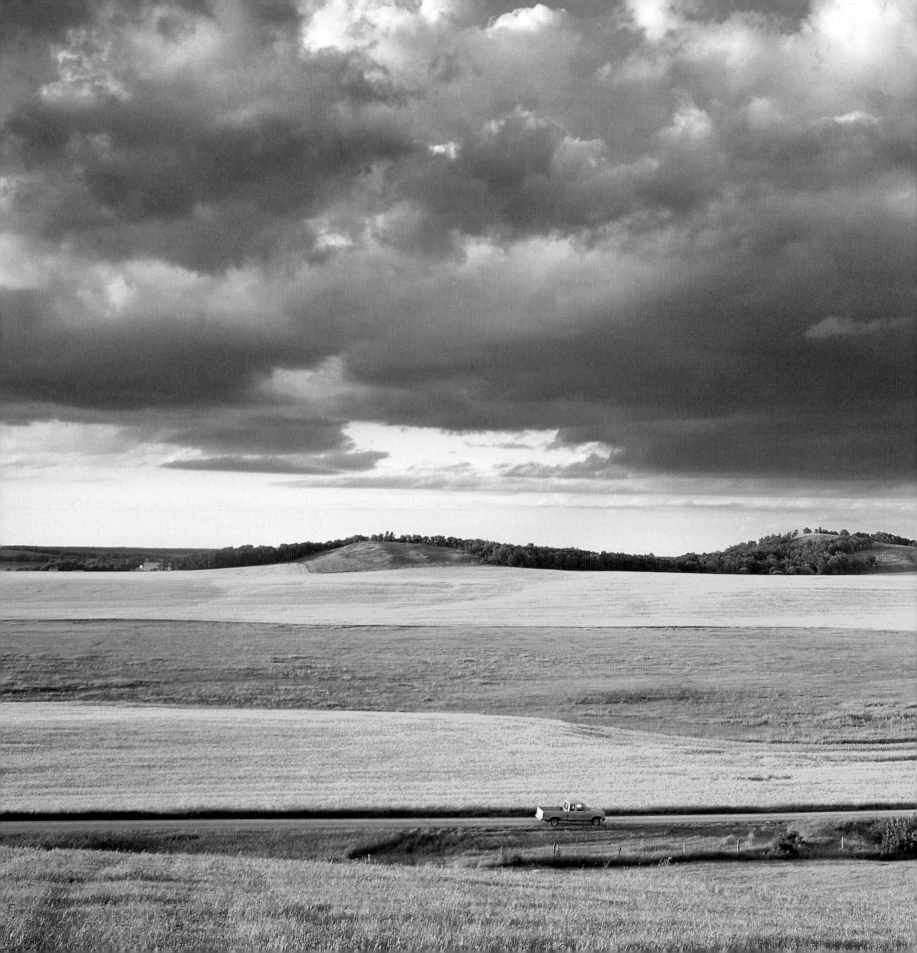

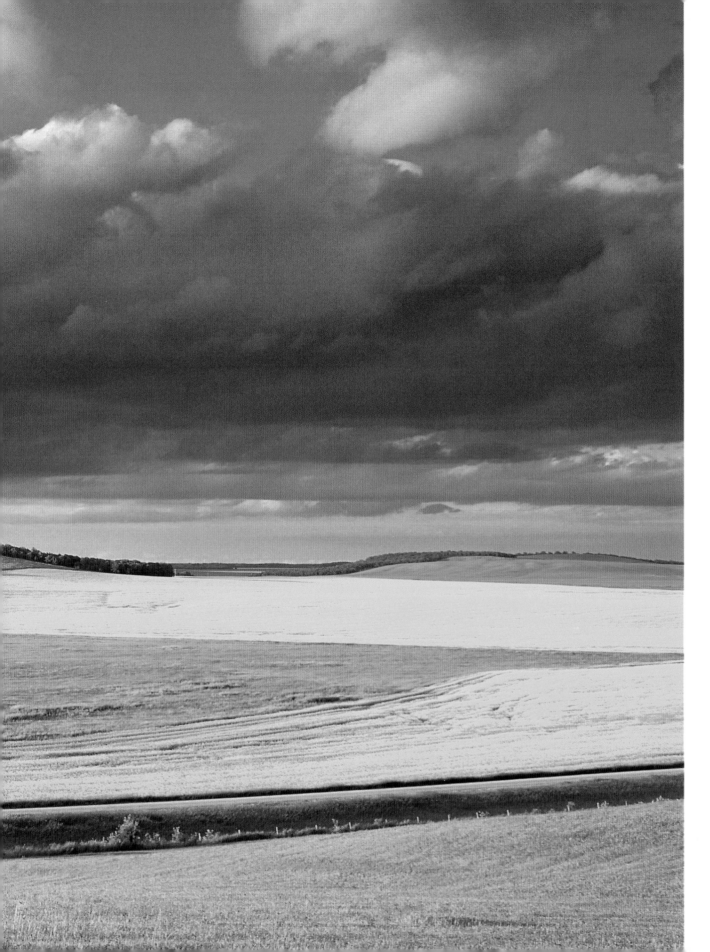

Crops create geometric patterns in the farmland near Holland, Manitoba. More than 25,000 farms checker the province.

Almost half the population of Manitoba lives in Winnipeg. The city boomed in the 1880s with the arrival of the railway. It continues to play a major role in the prairies as a commercial and cultural centre. The Royal Winnipeg Ballet is known around the world.

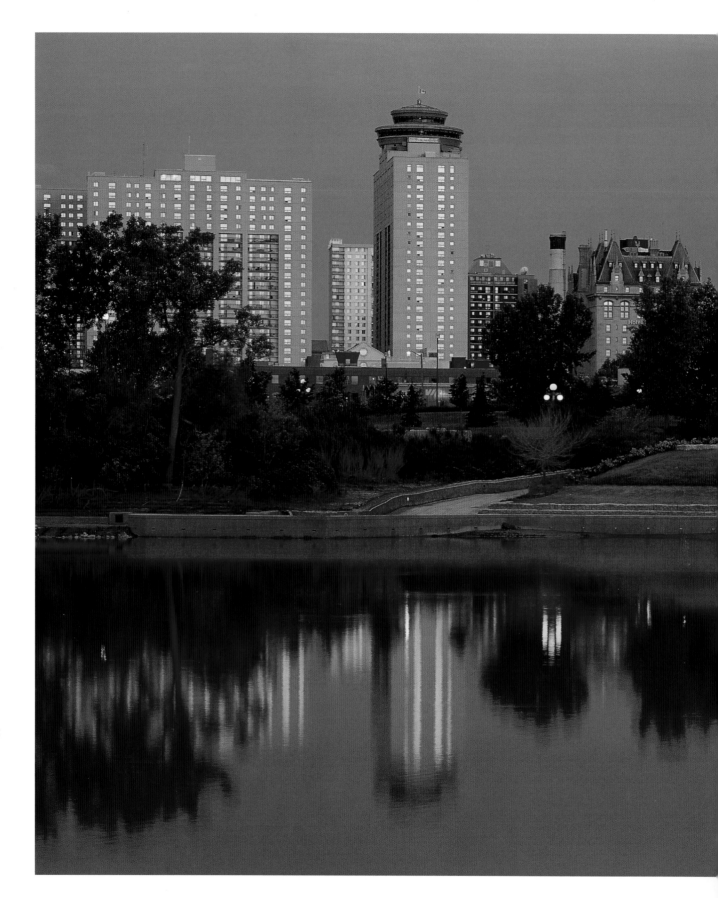

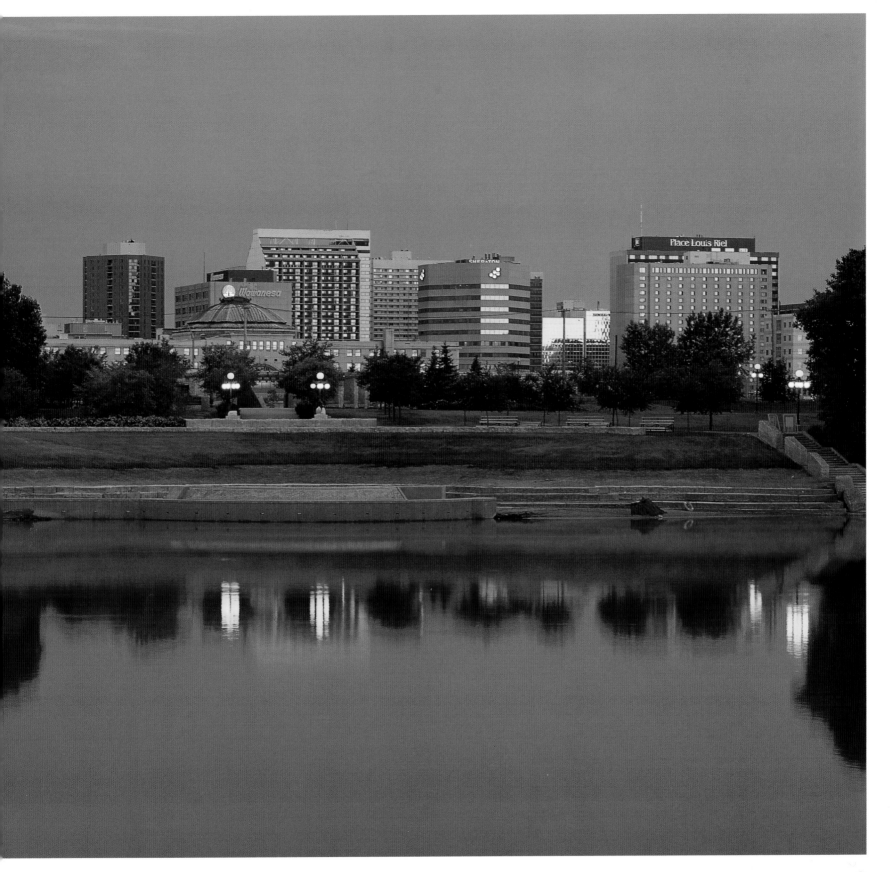

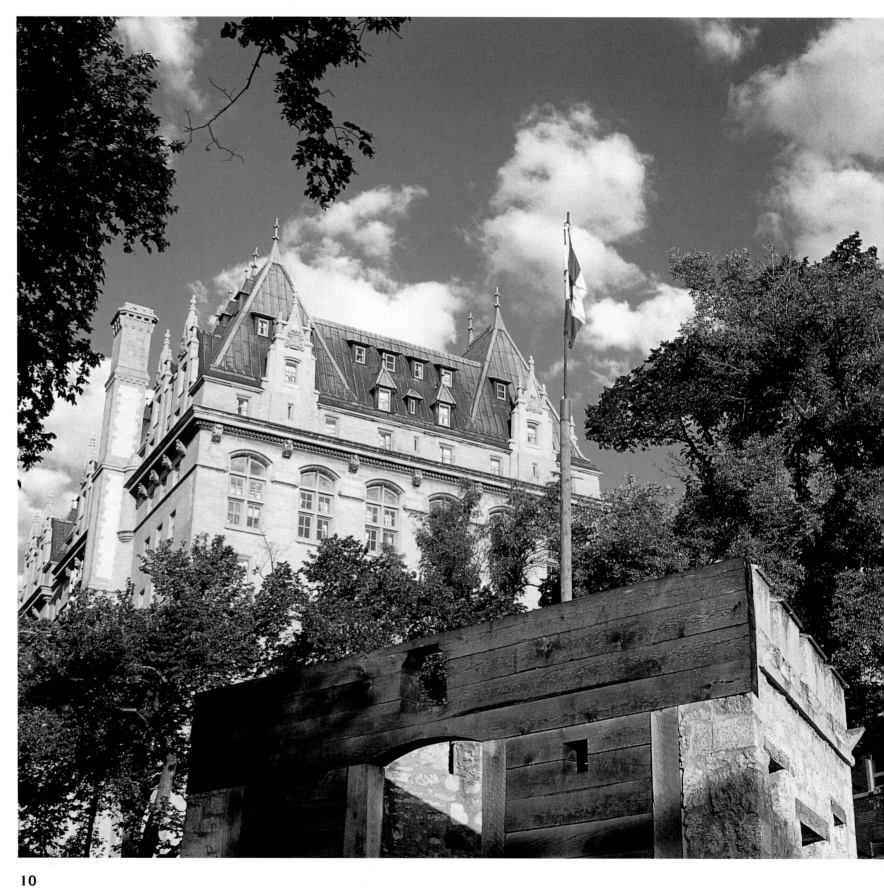

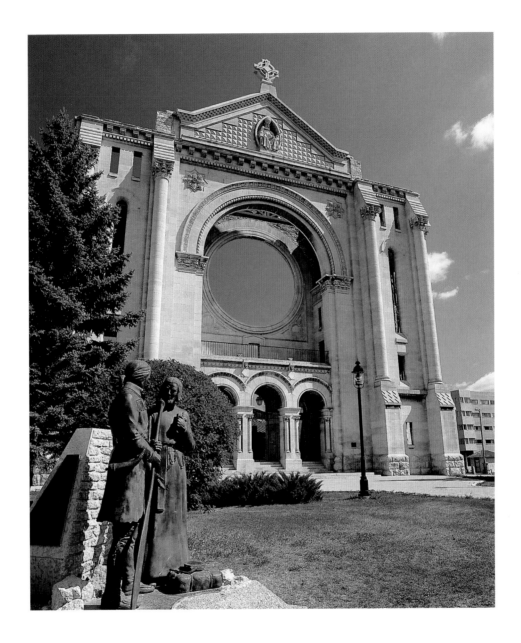

The St. Boniface Cathedral was built in 1908, but much of the original building was destroyed by fire in 1968. Louis Riel is buried in the church-yard here. After his execution in Regina in 1885, emotions were so high that his body had to be secretly transported to his family home in Manitoba.

This stone gate is all that remains of Upper Fort Garry, a nine-teenth-century Hudson's Bay Company post. From here, the company oversaw the fur trade in the Red River Valley and farther west.

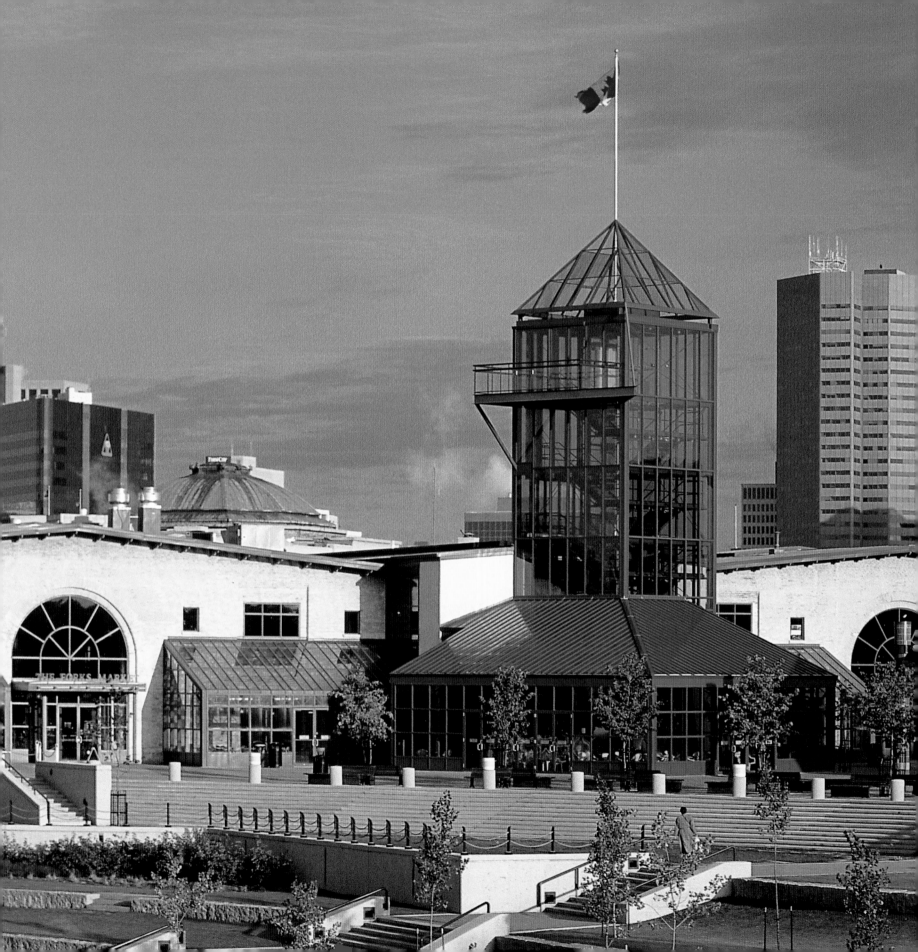

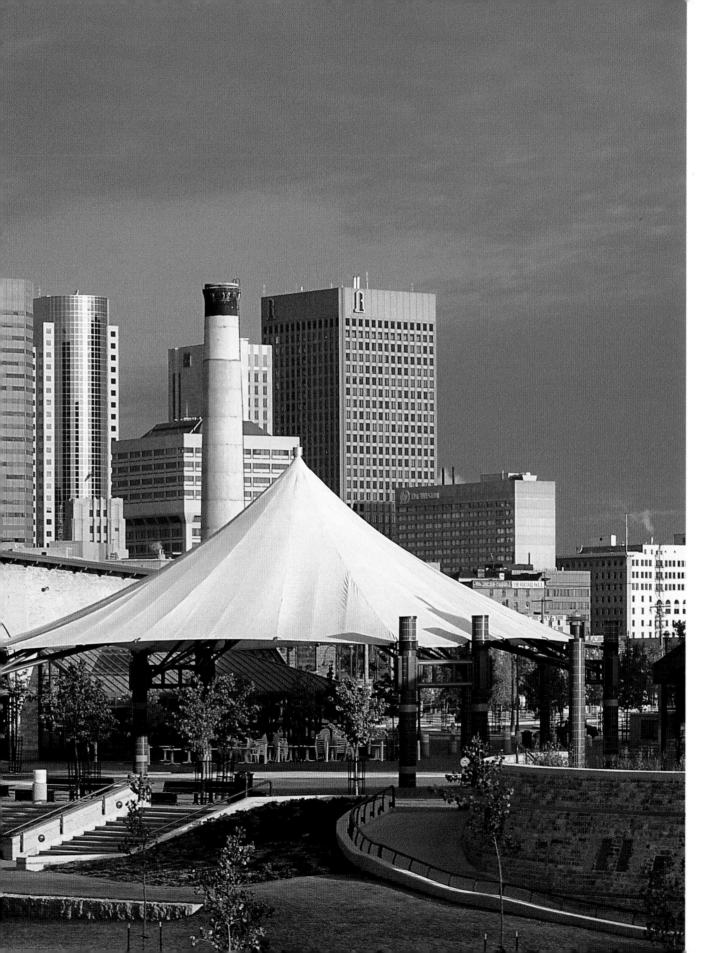

Winnipeg's city centre is known as The Forks, a name first used by French explorer La Vérendrye. The Forks Market, housed in the old stable of the Grand Trunk Pacific Railway, offers an array of local and exotic foods.

13

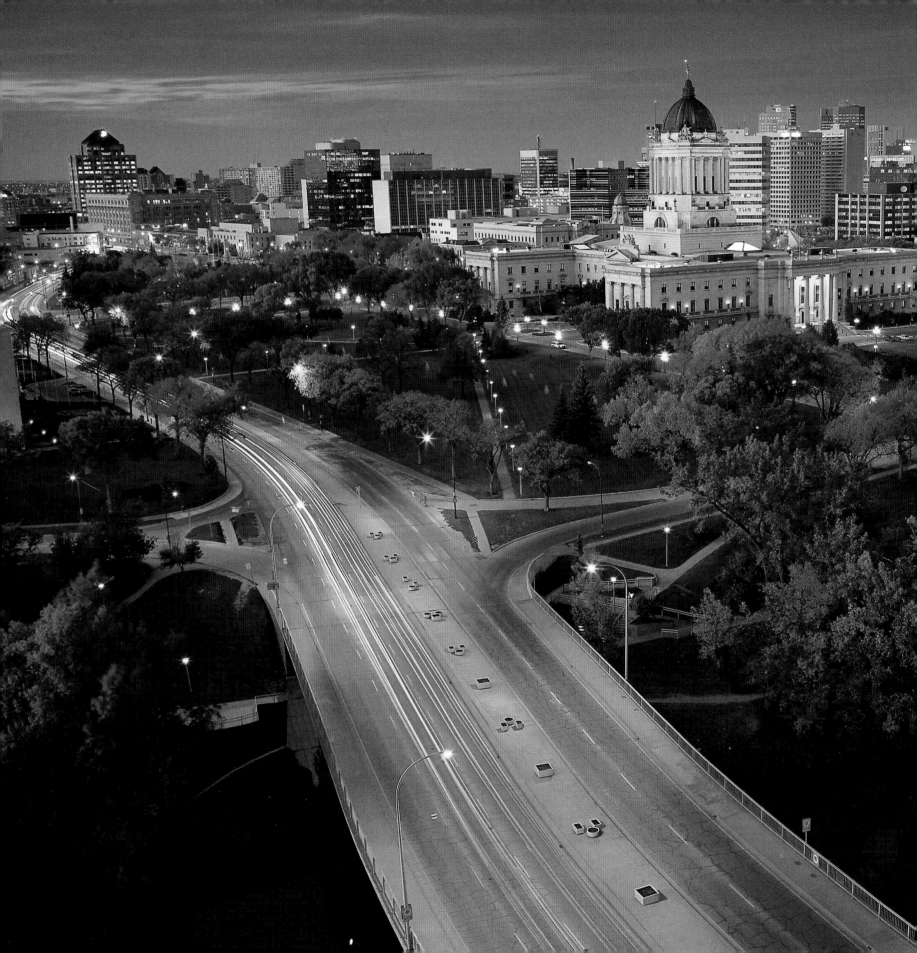

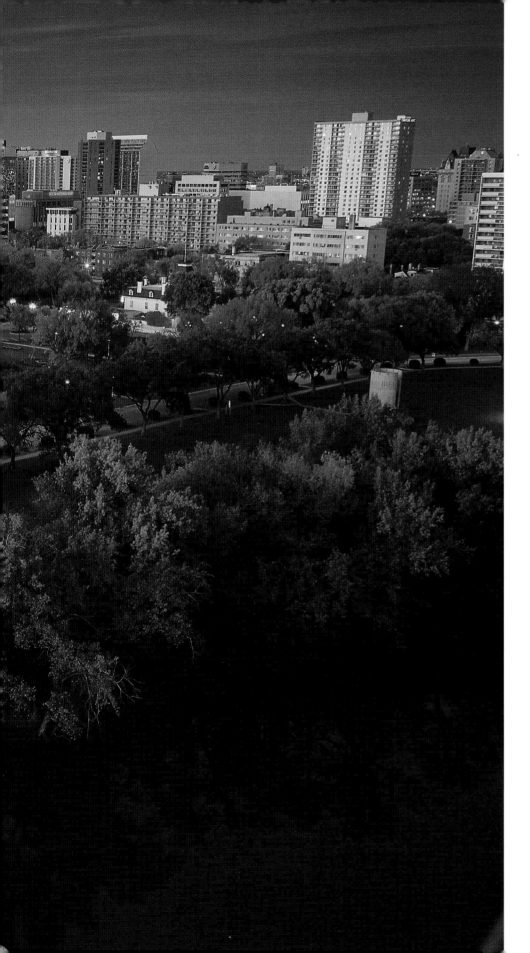

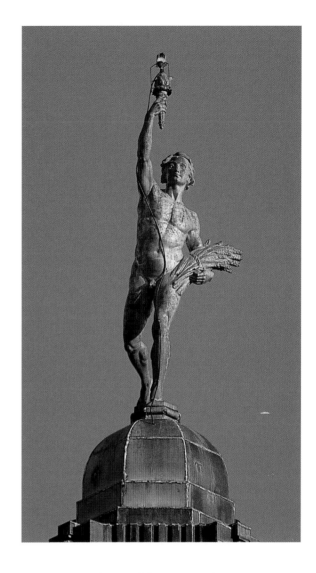

Known as the Golden Boy, this four-metre-high statue by Charles Gardet adorns Winnipeg's Legislature. The boy holds a torch symbolic of the enterprising prairie spirit.

The rare Tyndall stone and neoclassical style of Winnipeg's Legislature is known and studied by architects around the world. Completed in 1919, it is now one of Canada's most valuable buildings.

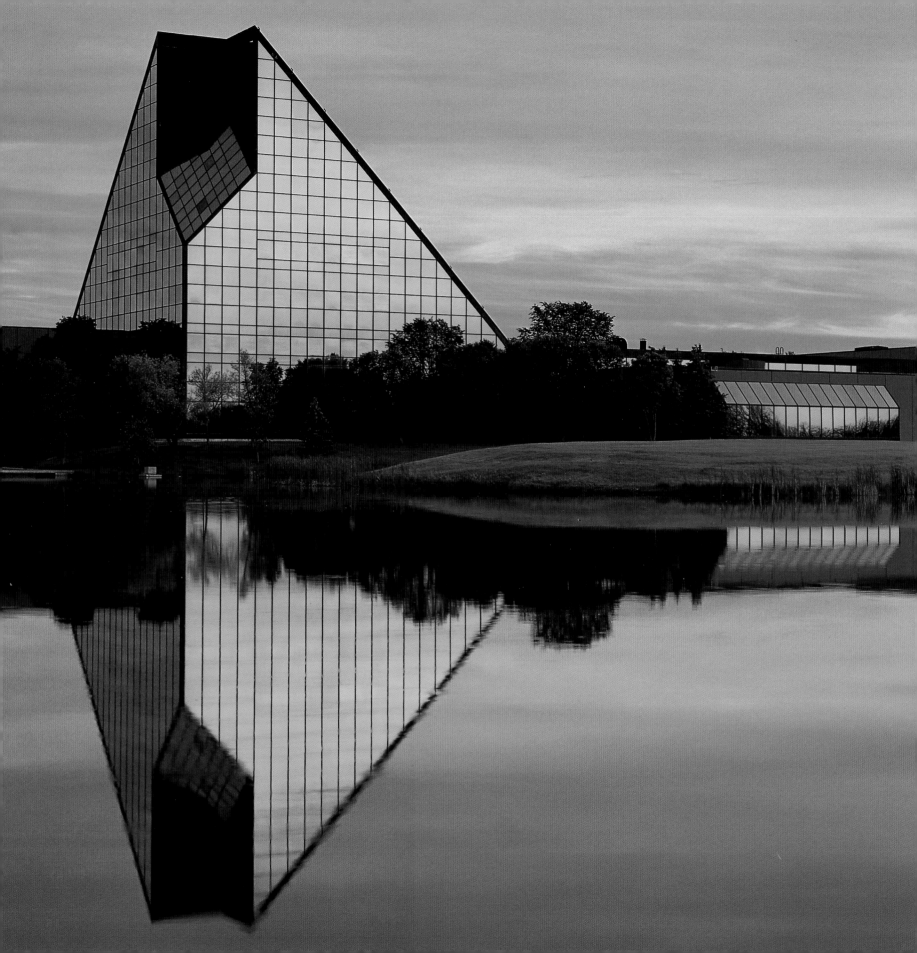

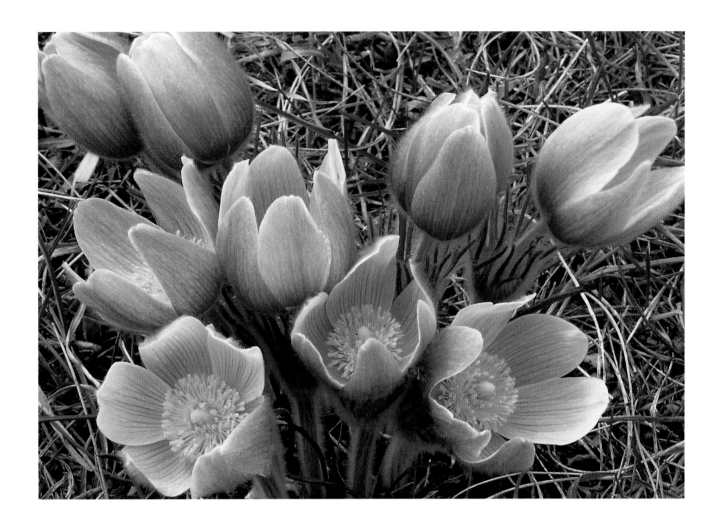

Manitoba's official flower, the prairie crocus, often appears before the last of the snow has melted in the spring. It is just one of hundreds of wildflowers that flourish in the tall-grass prairie.

The Royal Canadian Mint in Winnipeg boasts some of the world's most advanced technology. Each year, the facility can make up to three billion coins—all of Canada's circulation coins plus currency for about fourteen other countries.

OVERLEAF –
Sunflower crops were cultivated by North American First Nations long before the arrival of Europeans. The crops produced today in southern Manitoba are grown for their oil content. The seeds of these flowers are 40 to 50 percent oil.

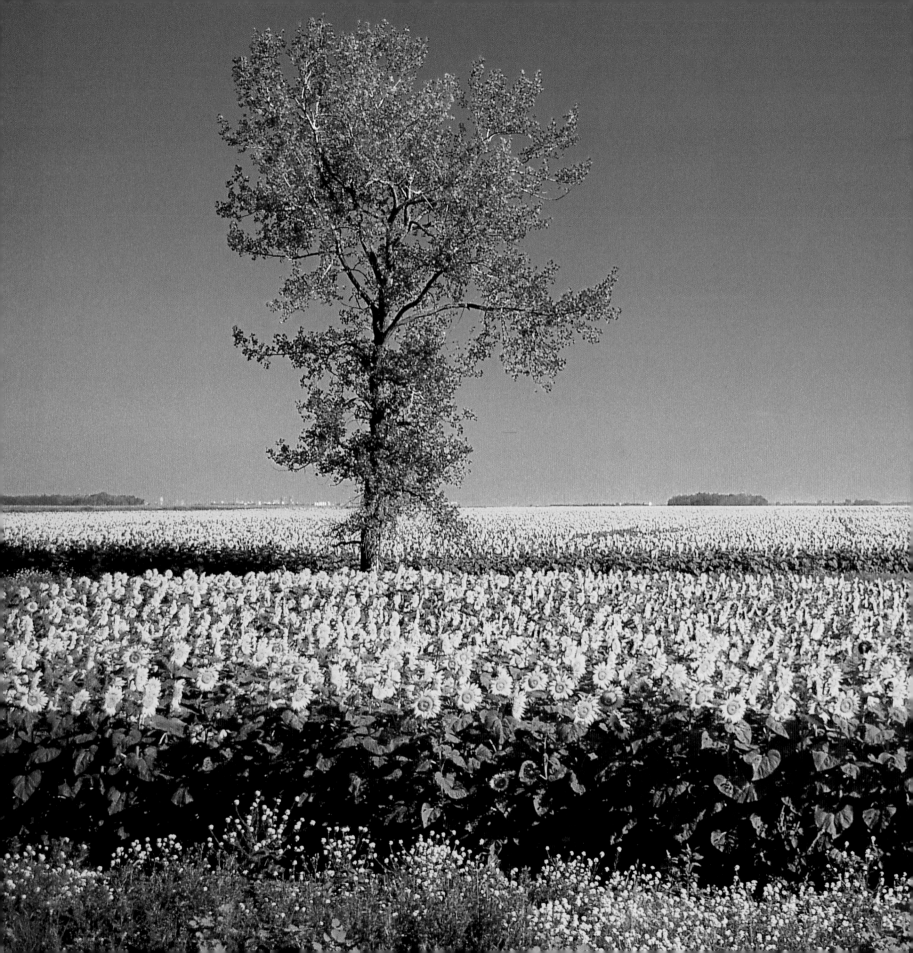

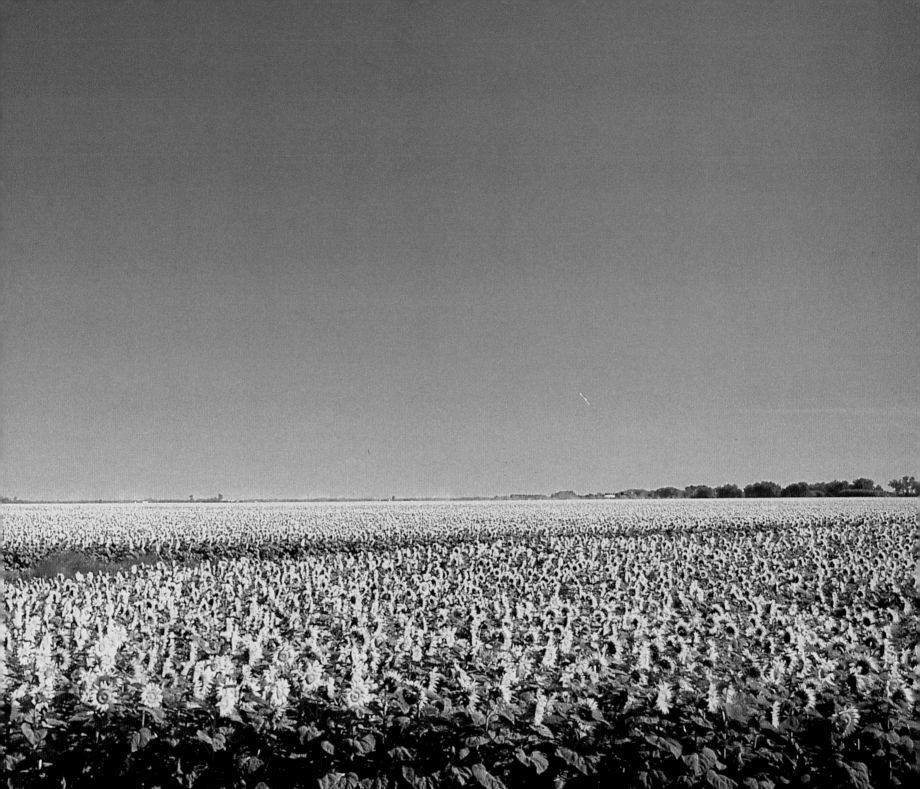

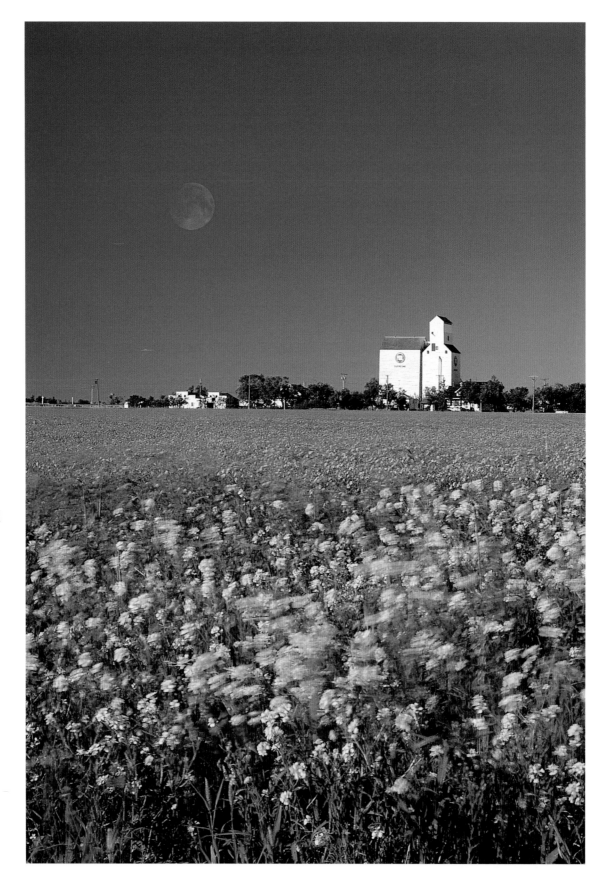

Southern Manitoba was covered by huge glacial lakes at the end of the last ice age. This land near Dufresne was under more than 80 metres of water. The lakes left behind rich soil, responsible for today's grain crops.

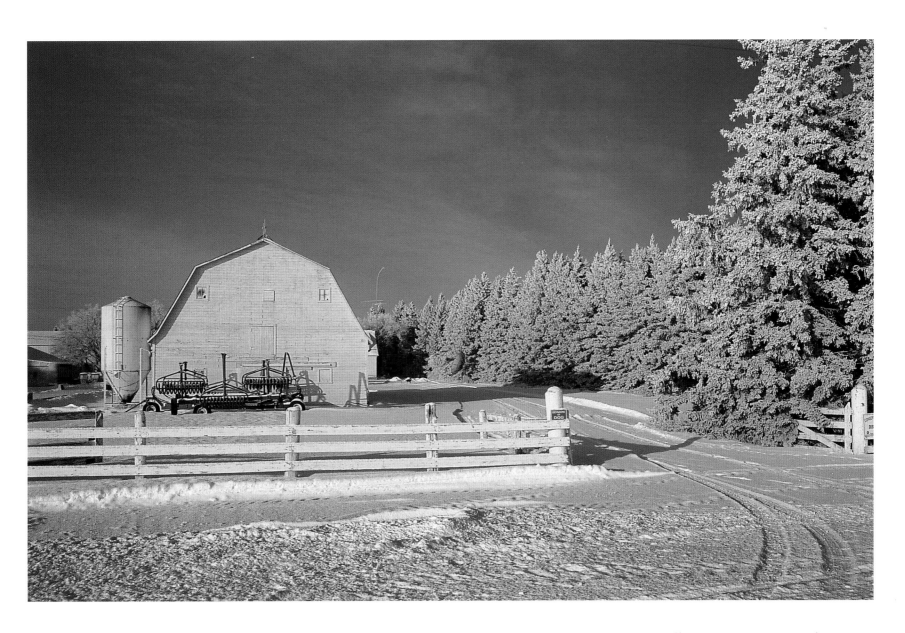

Manitoba's first frost usually arrives in September and the last is not until May. In midwinter, the average temperature drops to almost -20° Celsius.

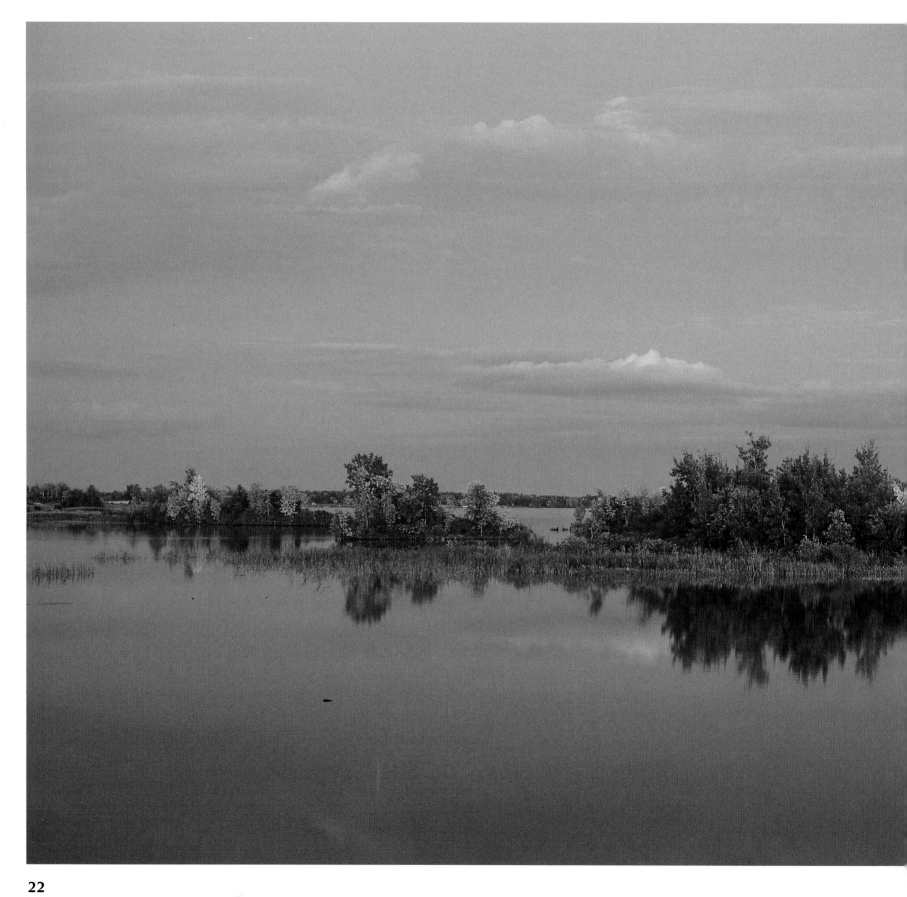

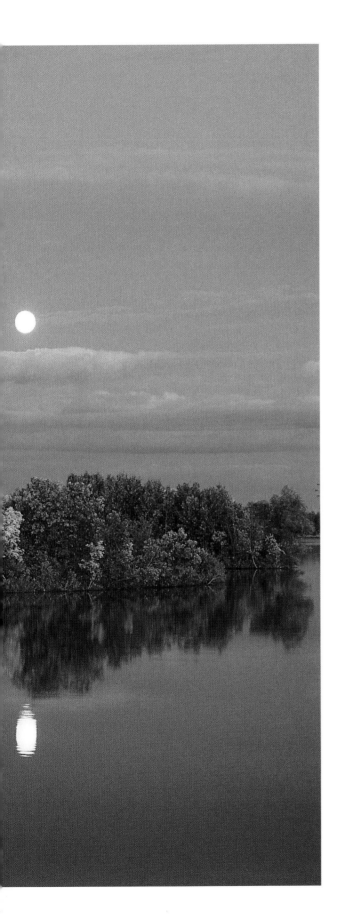

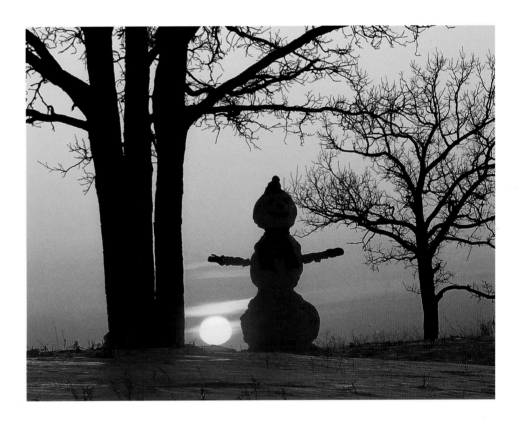

A trip to Birds Hill Provincial Park, just outside Winnipeg, is a popular family outing, and the perfect place to build snowmen. It is also a reminder of prehistoric Manitoba: archaeologists have retrieved the tusks and teeth of mammoths from this land.

For both First Nations and fur traders, the Winnipeg River was once an important channel on the route from Lake Winnipeg to Lake Superior.

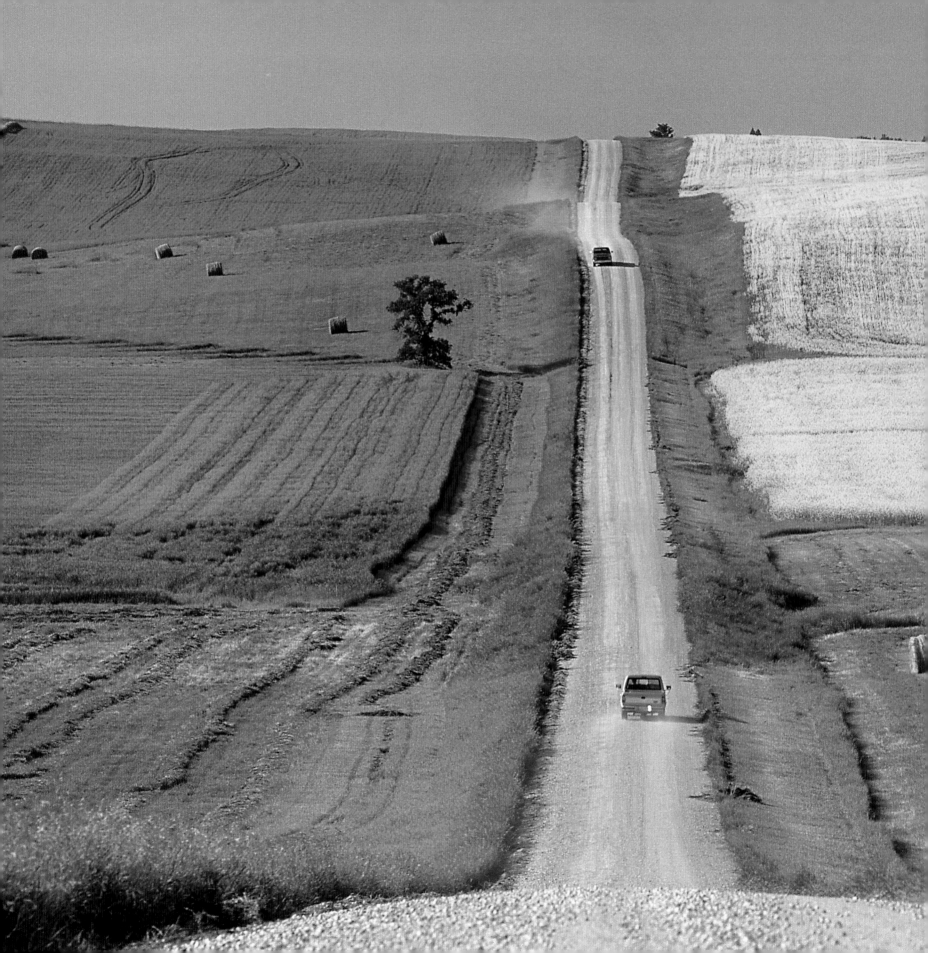

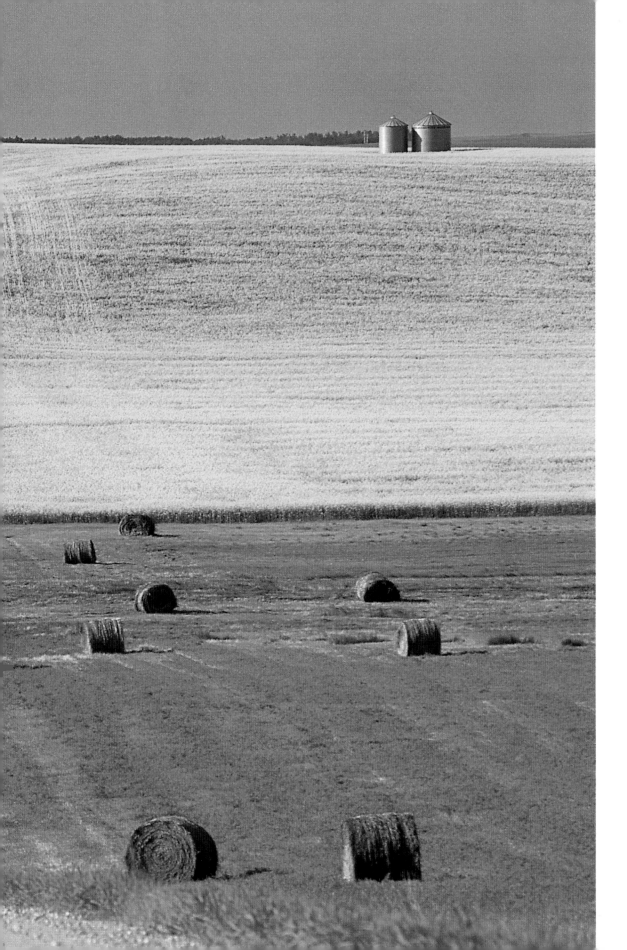

A gravel road stretches through the low, rolling landscape of the Tiger Hills. Outside the prairies, these would hardly be called hills. Manitoba's highest point, Mount Baldy, is only 831 metres above sea level.

25

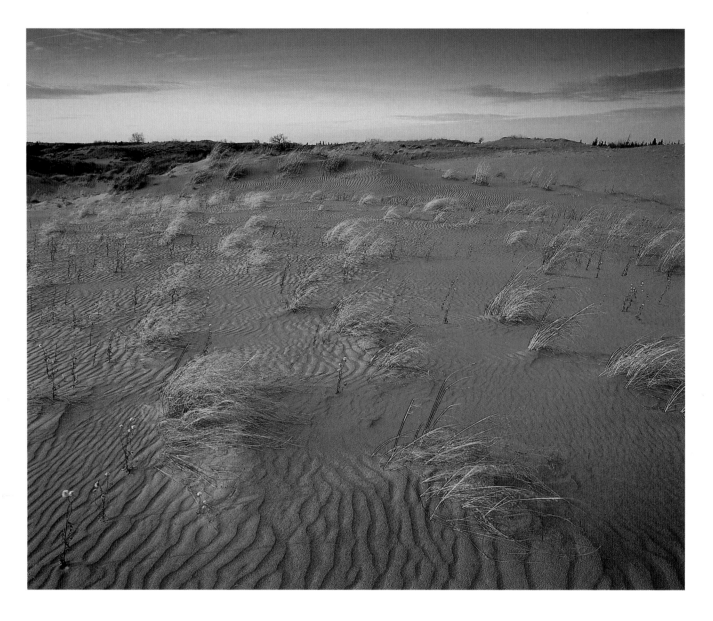

Though not dry enough to qualify as an official desert, the Spirit Sands area in Spruce Woods Provincial Park is home to lizards, snakes, and cacti. Covered wagons reminiscent of those used by Manitoba's first European settlers take visitors on tours of the area.

The International Peace Garden was established in 1932 along the border between Manitoba and North Dakota. It honours the world's longest undefended border.

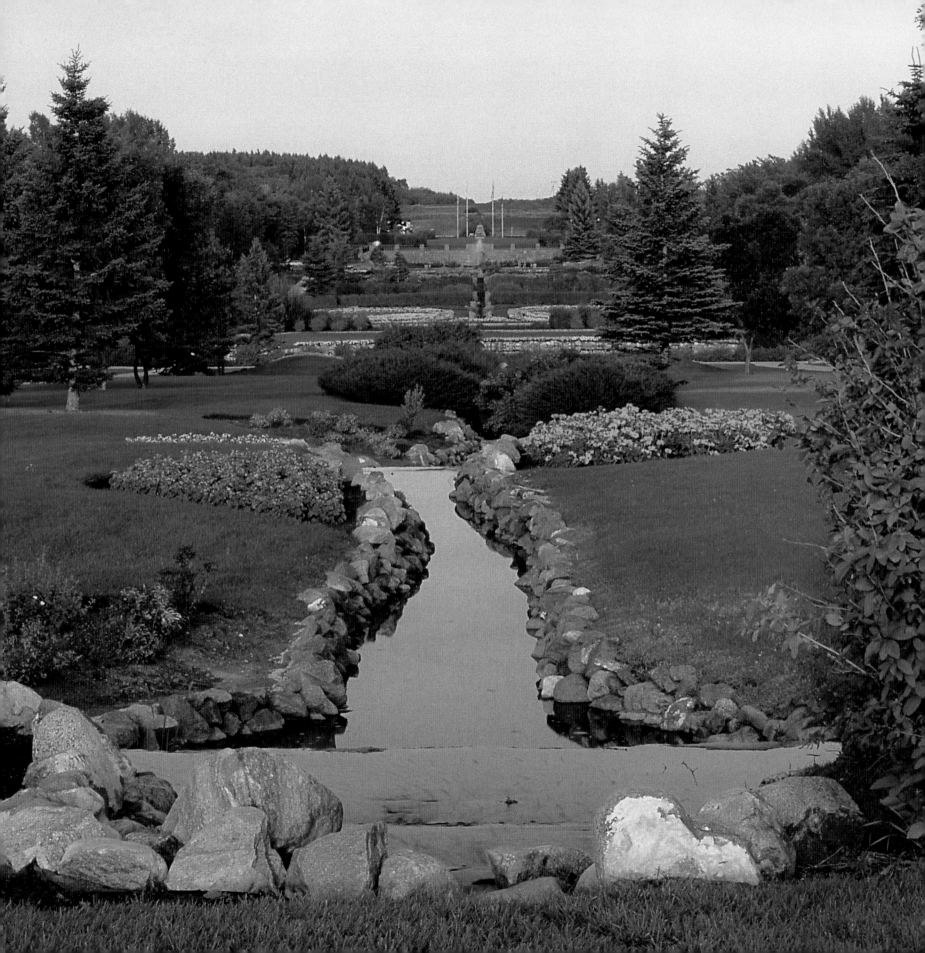

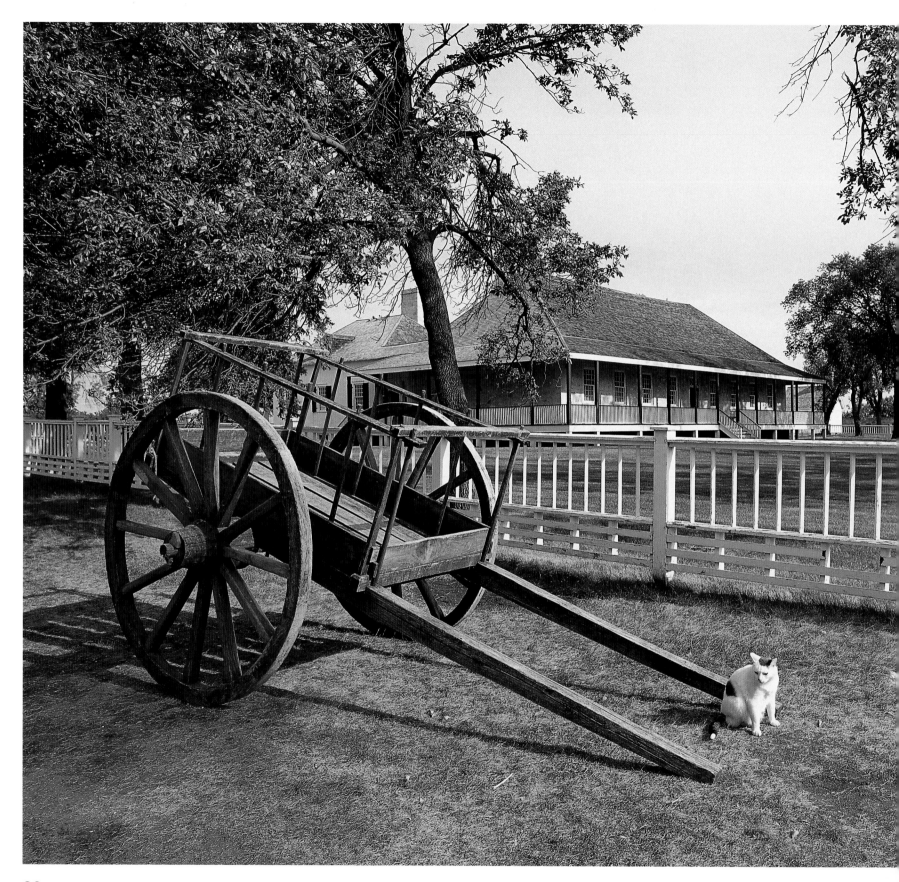

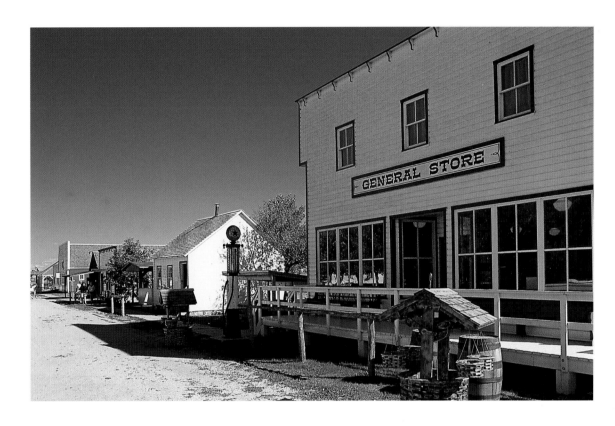

At Mennonite Heritage Village, visitors discover the culture of Mennonites who settled the Steinbach area in 1874. The village includes farm buildings, houses, a traditional church, and a unique shingled windmill.

Red River carts, such as this one at Lower Fort Garry Historic Site, were first used by prairie settlers in the early 1800s. They were later used extensively by the Hudson's Bay Company to carry furs from Canada to the Mississippi River, where the furs were loaded onto ships bound for Britain.

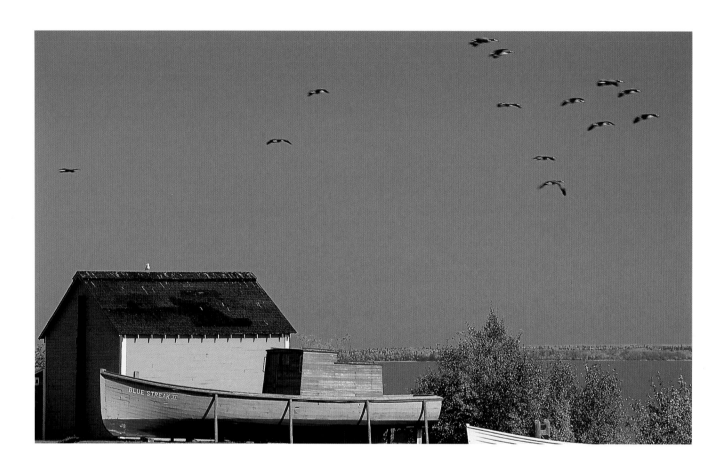

Hecla Provincial Park includes several islands in Lake Winnipeg. Until 1897, this area was an independent Icelandic settlement, with its own school, churches, and economy.

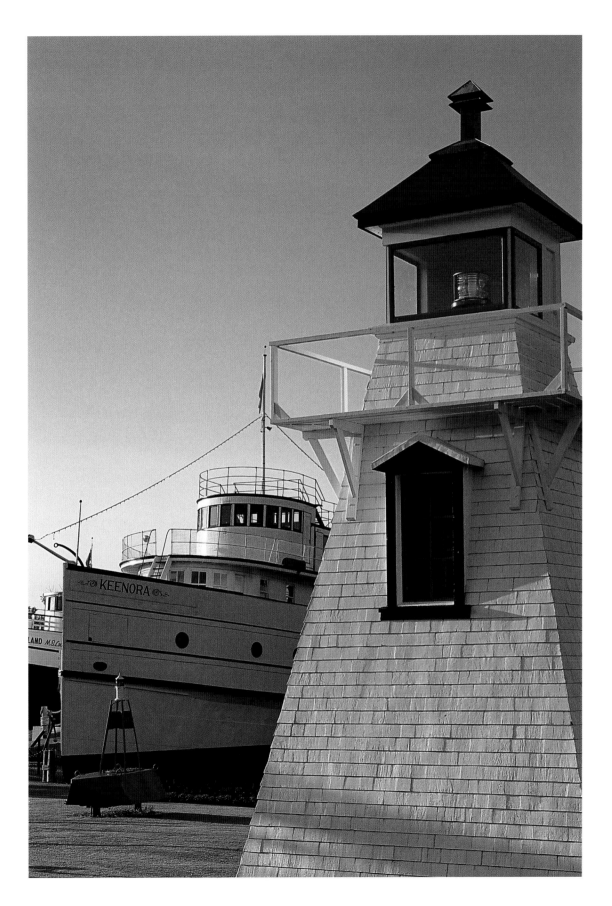

The Marine Museum in Selkirk Park celebrates Manitoba's nautical history. The five ships on display include a passenger steamship and an icebreaker.

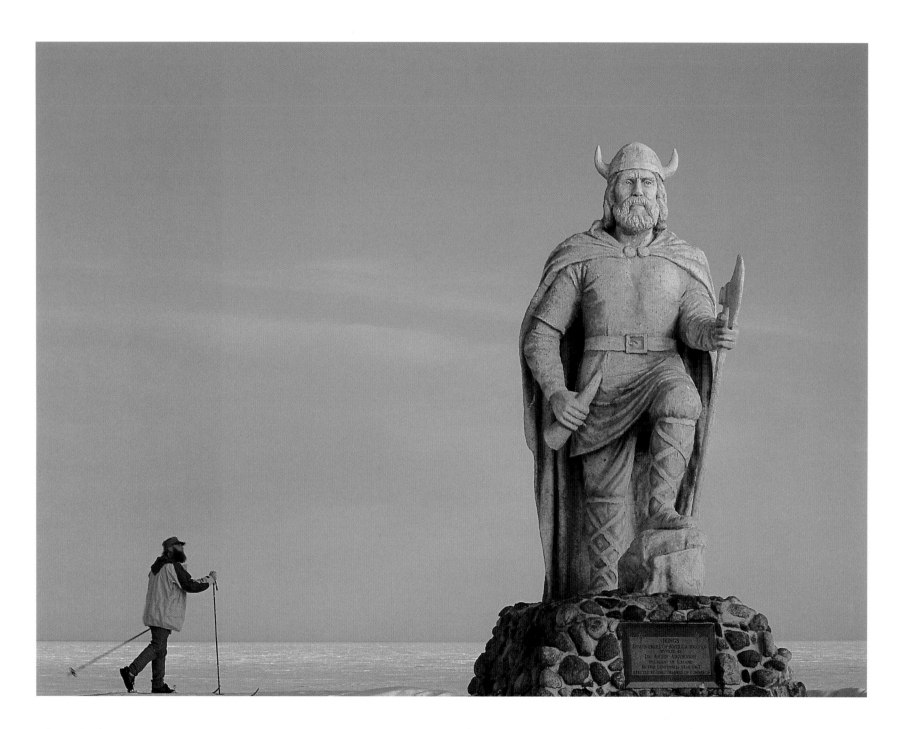

The Viking statue in Gimli pays tribute to the heritage of Icelandic
Canadians. Gimli means "great hall of heaven" and the town hosts
an Icelandic festival—Islending a dagurrinn—each summer.

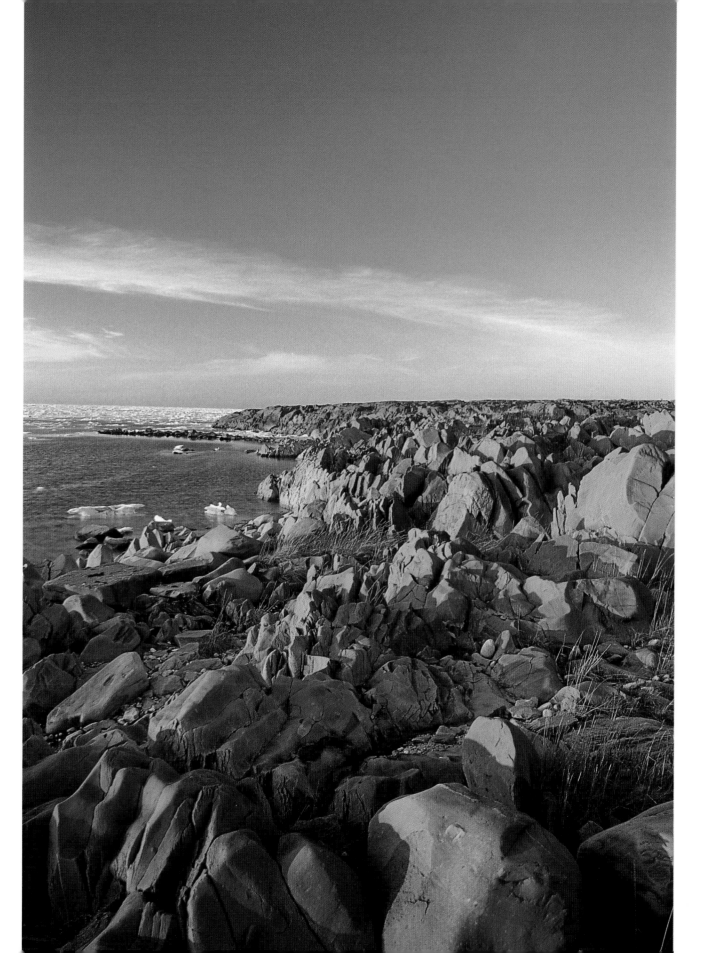

The land along the Hudson Bay coast is locked in ice for eight months of the year. Even in summer, huge chunks of ice float near the shore.

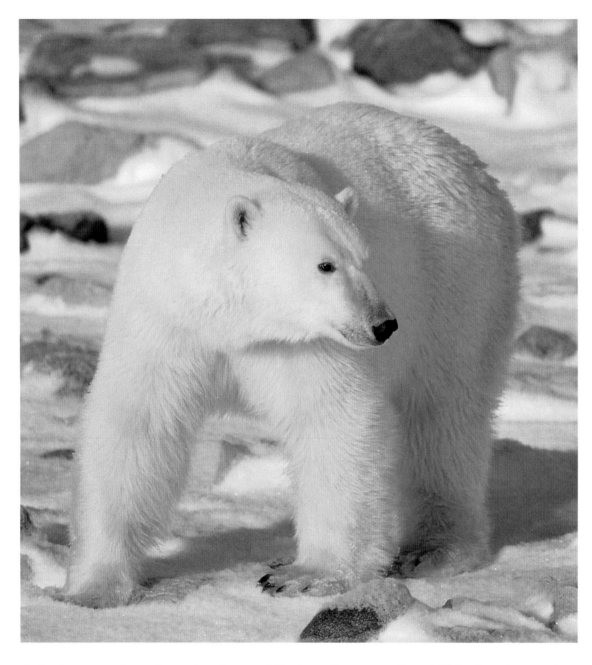

Polar bears gather along the shore of Hudson Bay near Churchill in October and November. When the bay freezes over, they winter on the ice, hunting for seals.

More than 400 plant species grow in the tundra near Churchill. Carpeted with moss and lichen, the land bursts into colour each June with the blooms of delicate wildflowers.

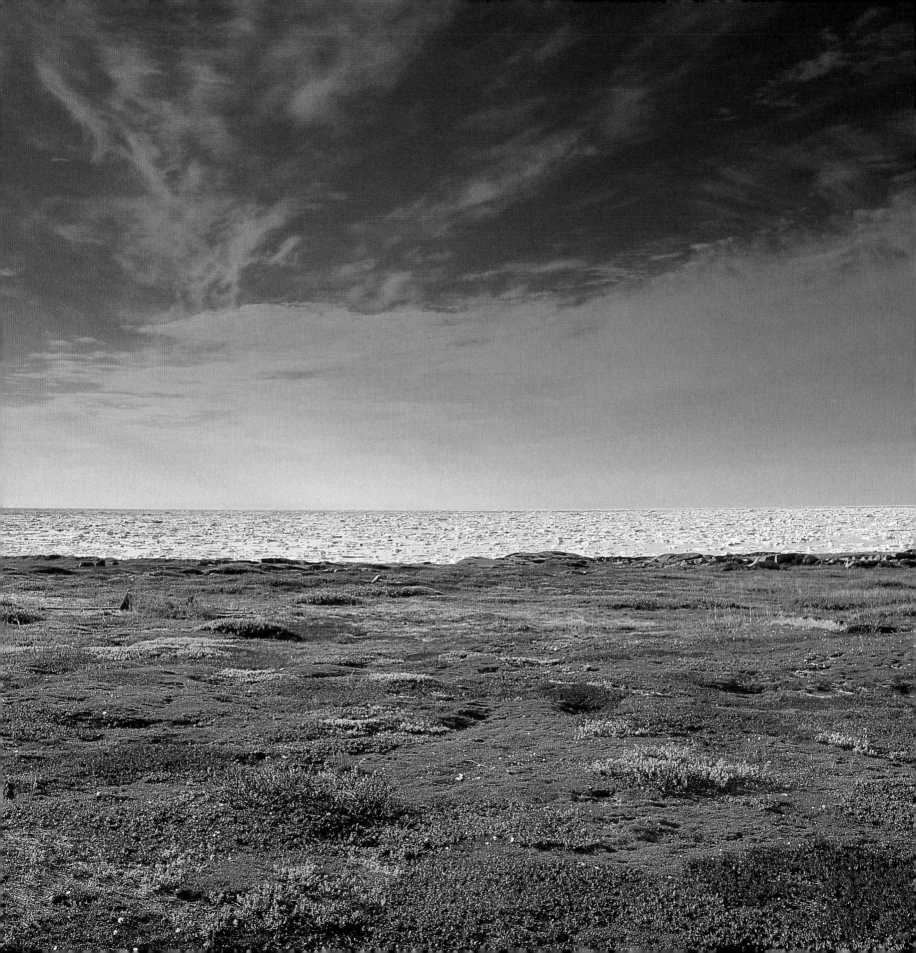

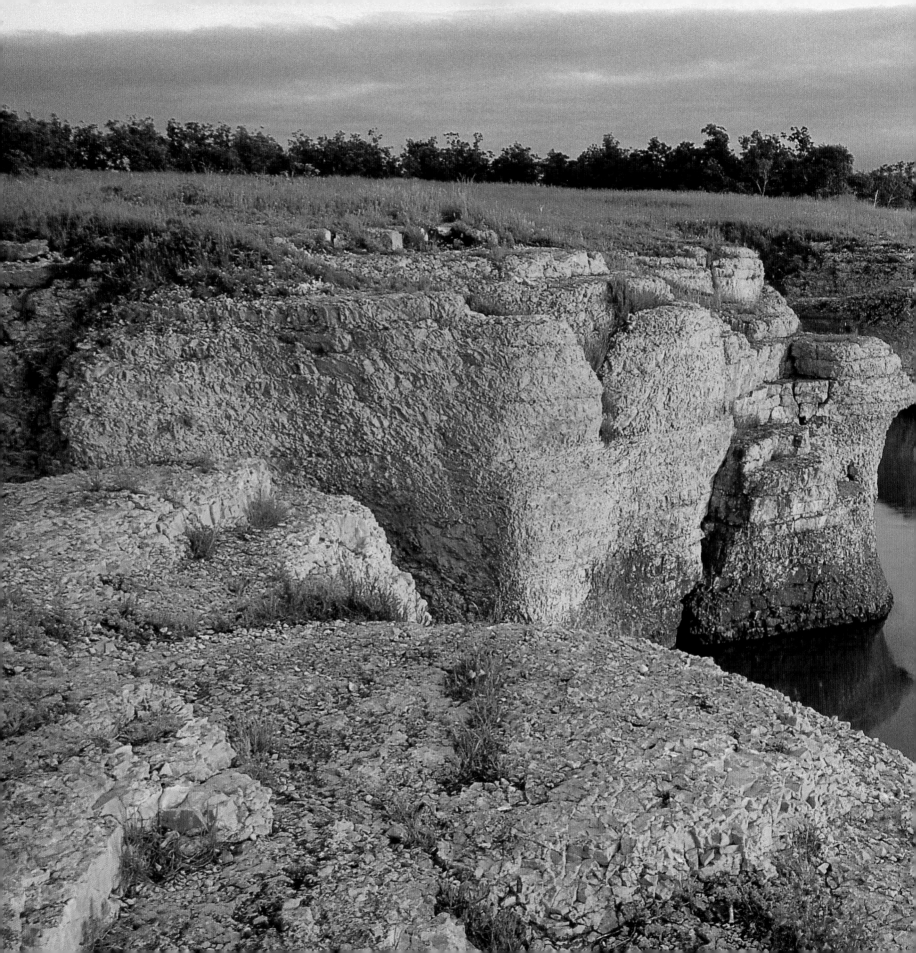

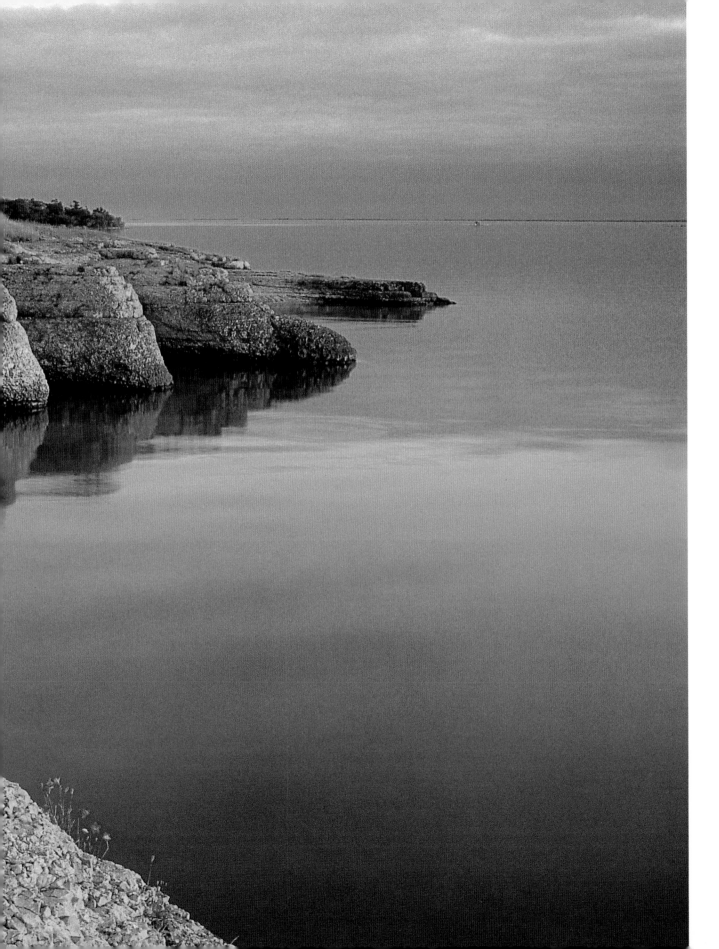

Fine sand beaches
alternate with the
rocky shoreline of
Lake Manitoba. This
is just one of more
than 100,000 lakes in
the province.

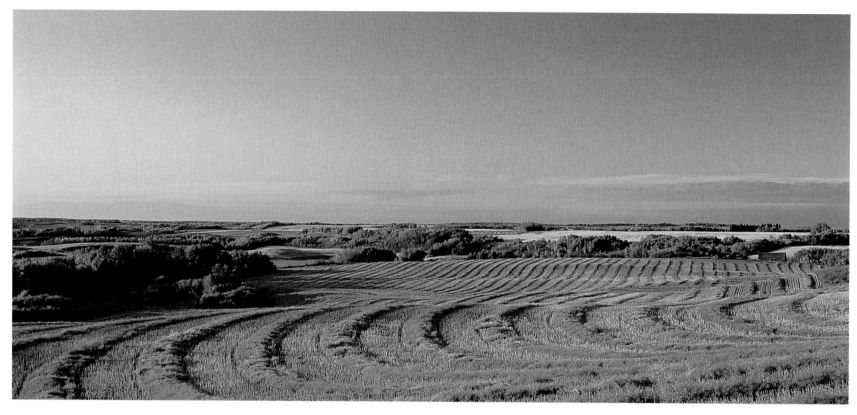

Riding Mountain National Park, home to the world's largest
black bears, has been named a Biosphere Reserve by
UNESCO. It serves as an international model of how
humans and nature can coexist.

Whirlpool Lake is one of several small lakes that dot Riding Mountain
National Park, northwest of Winnipeg. A cabin nearby was built by
Grey Owl, a renowned author and conservationist. Grey Owl was
thought to be a native, but upon his death the public discovered that
he was Archibald Stansfeld Belaney, born in England.

OVERLEAF –
Pisew Falls on the Grass River are the highest accessible falls in
Manitoba. Eighteenth-century explorer and Hudson's Bay Company
employee Samuel Hearne once travelled this river.

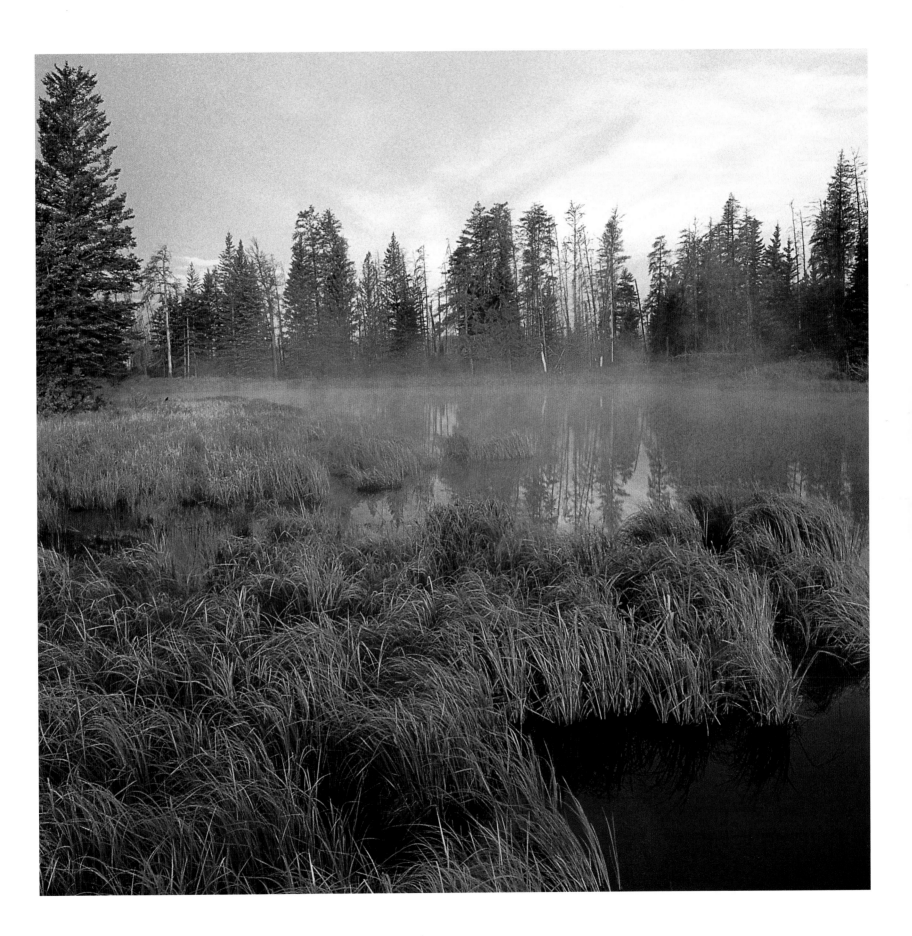

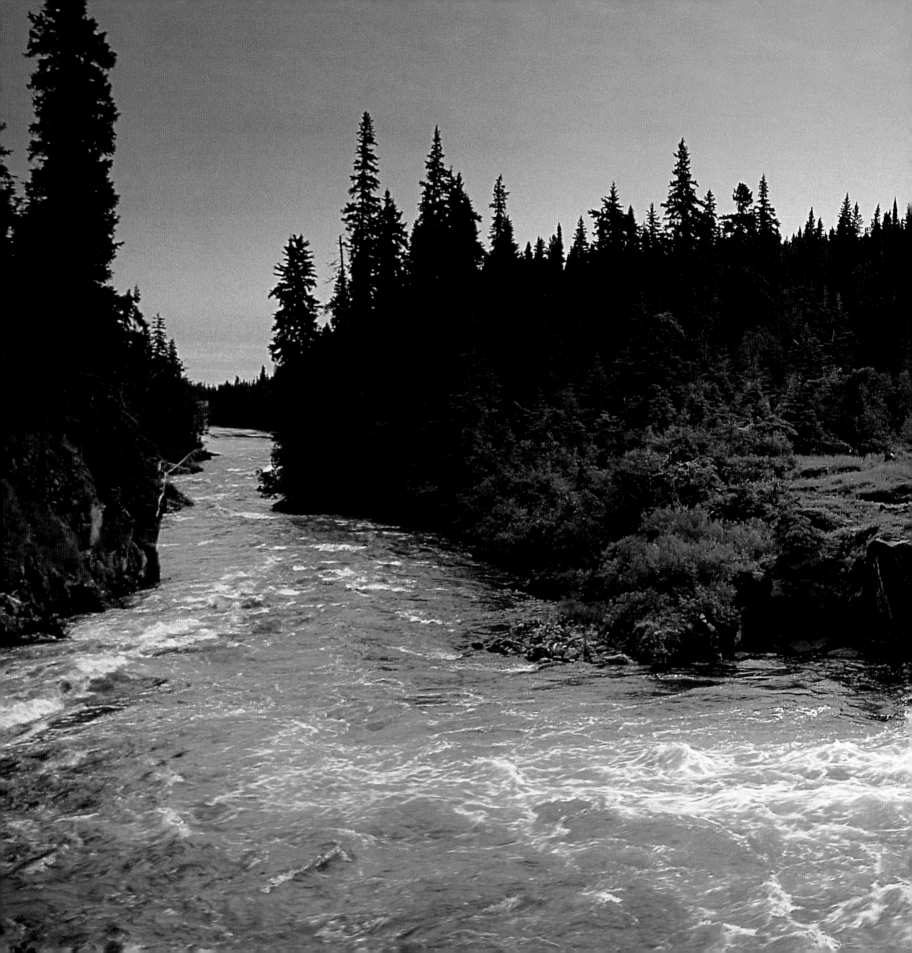

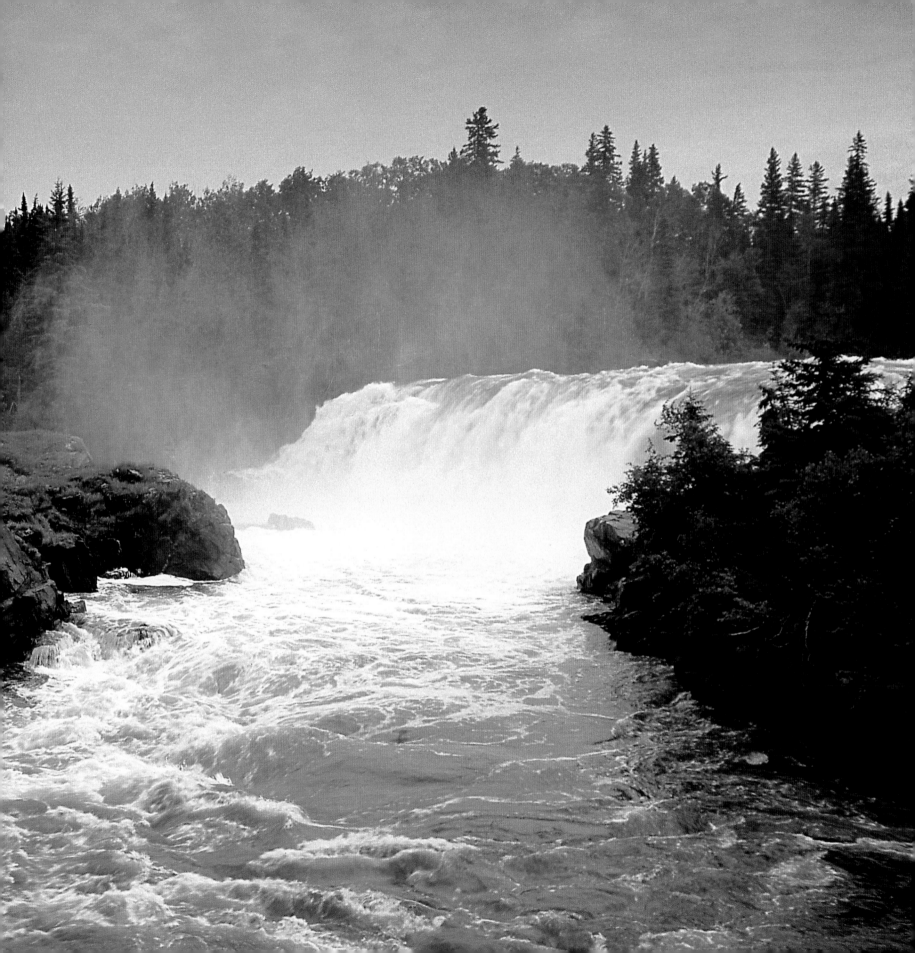

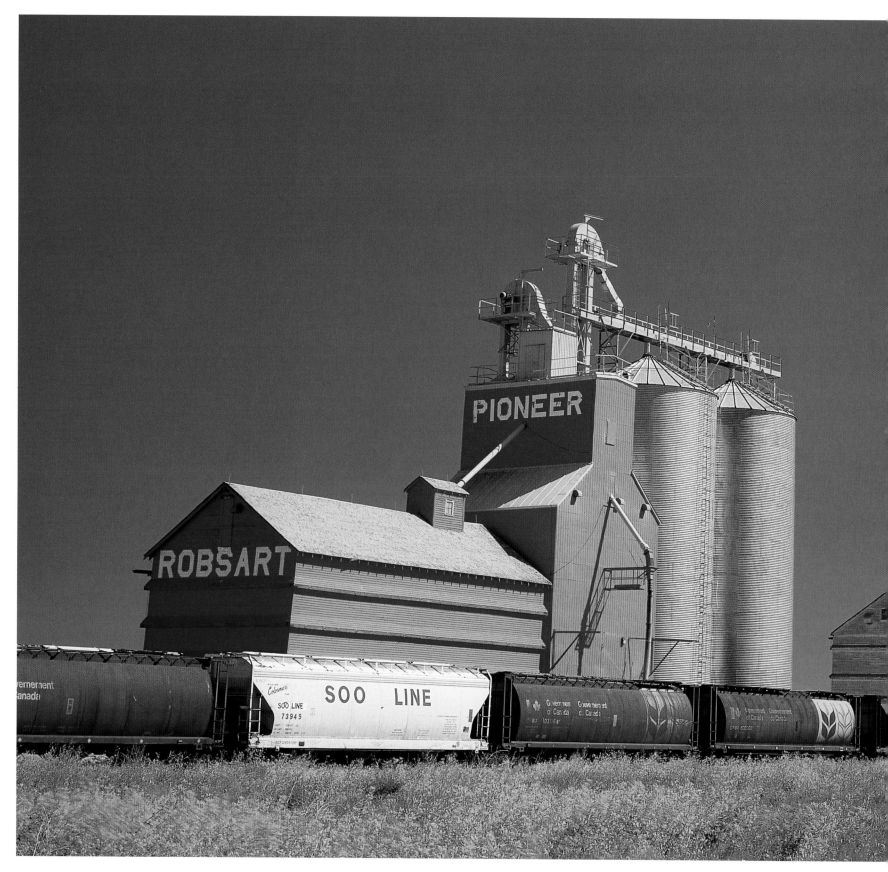

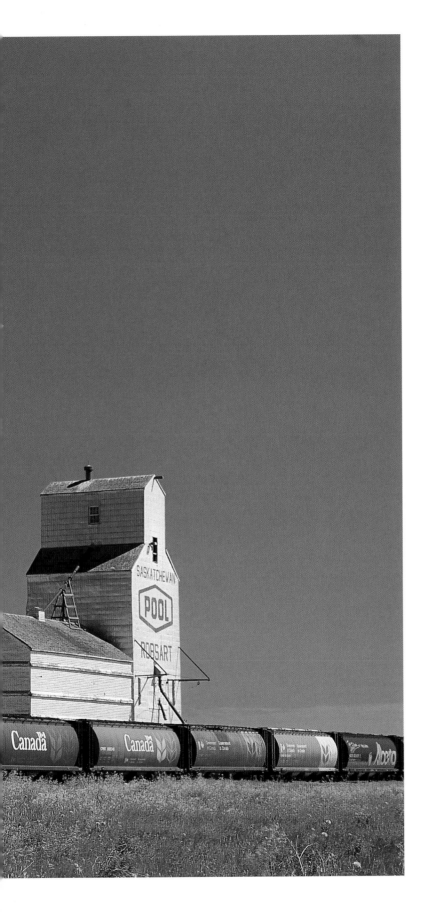

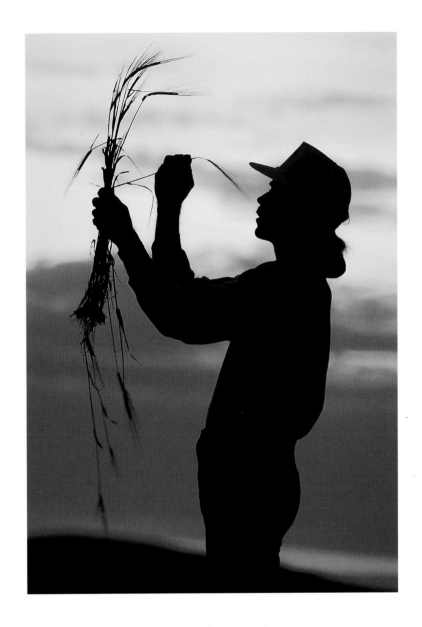

Alberta, Saskatchewan, and Manitoba grow 90 percent of Canada's barley and rye.

Wheat, the staple of Saskatchewan's economy, is not indigenous to North America. It was brought by some of the first settlers to North America. The first wheat was planted in western Canada in 1754 in the Carrot River Valley.

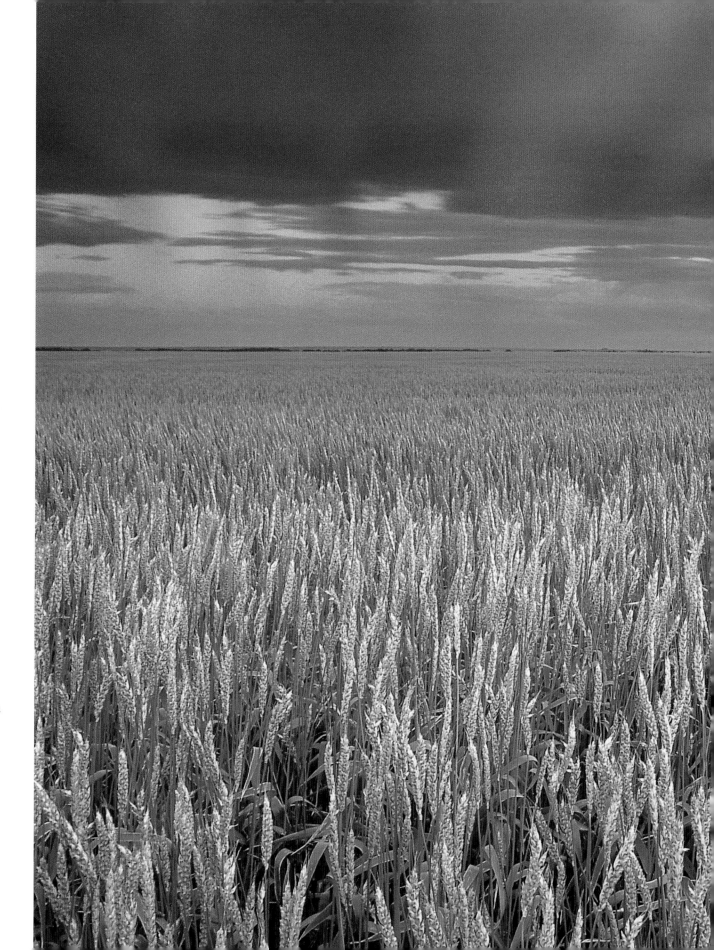

Saskatchewan is North America's largest wheat producer. The province grows about two billion dollars worth each year.

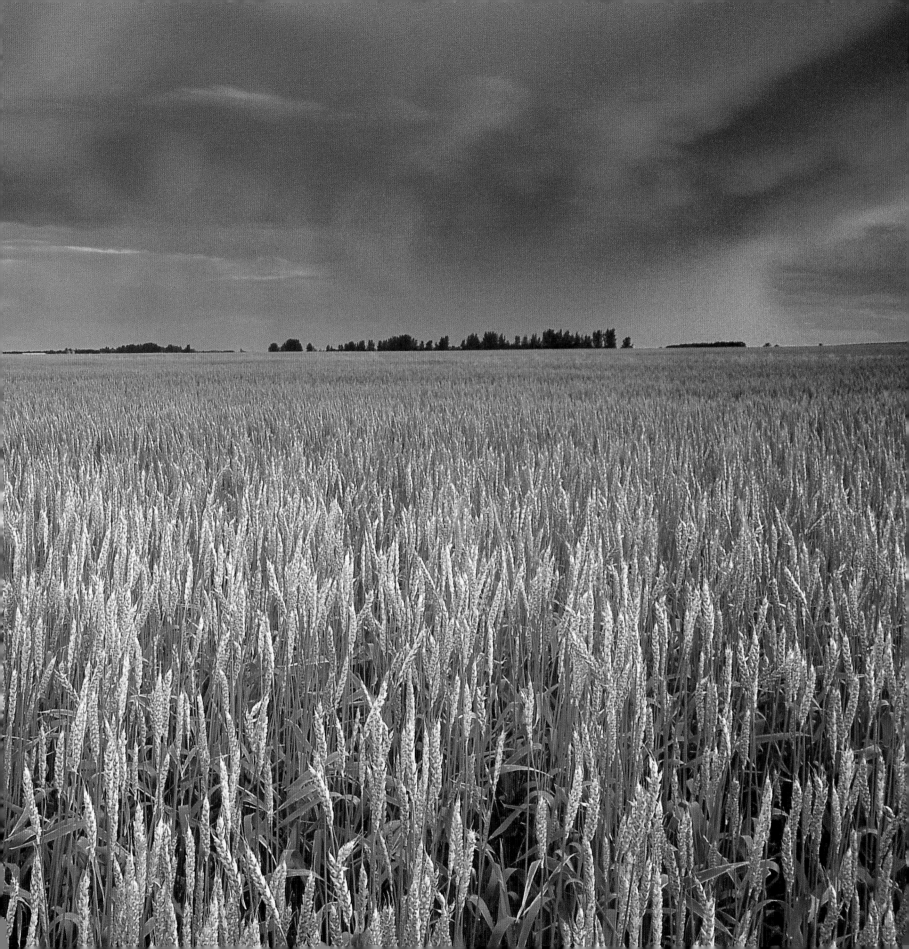

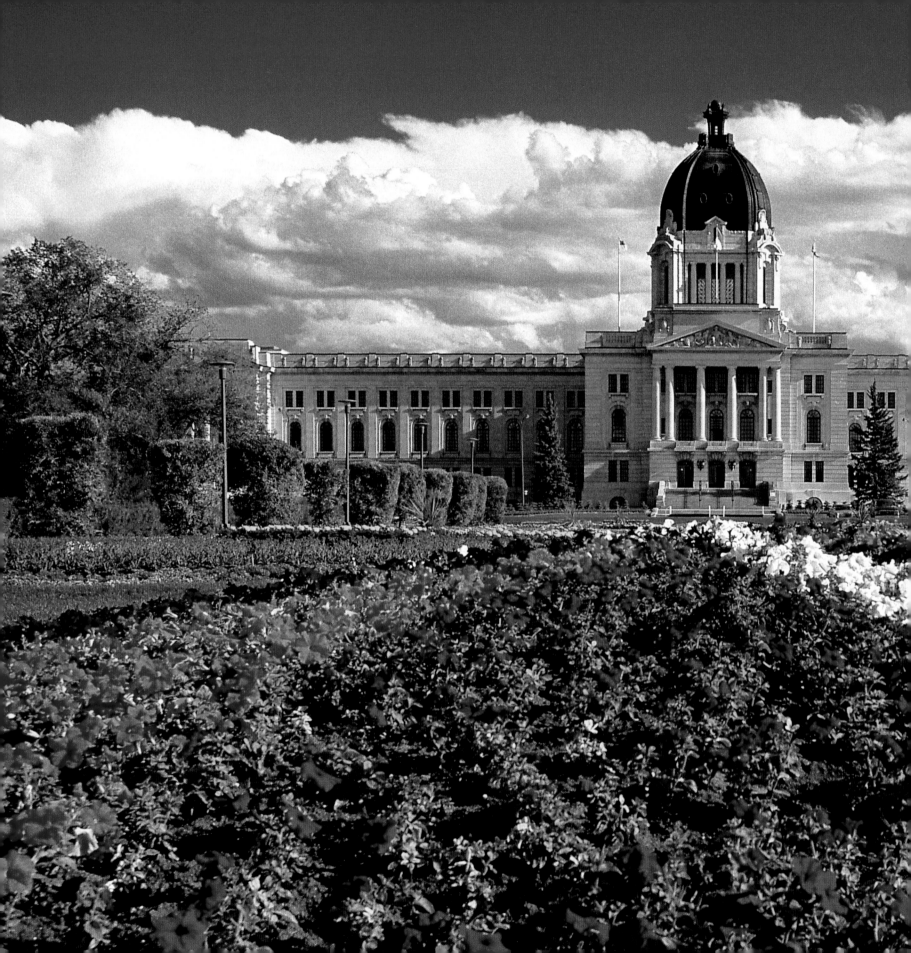

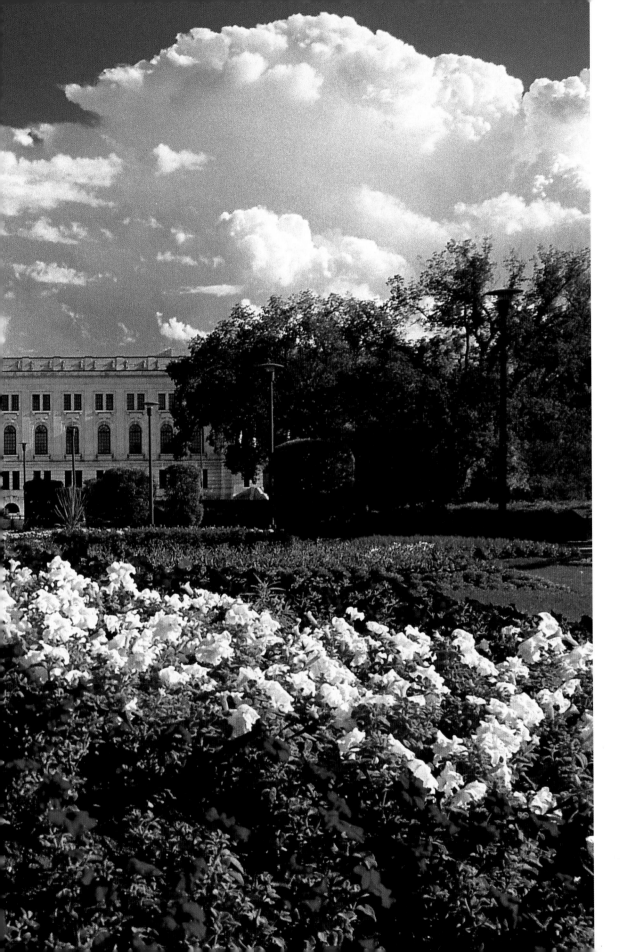

Regina, Saskatchewan's capital, was originally named "Pile o' Bones" after the high stacks of bison bones left on the river banks by native hunters.

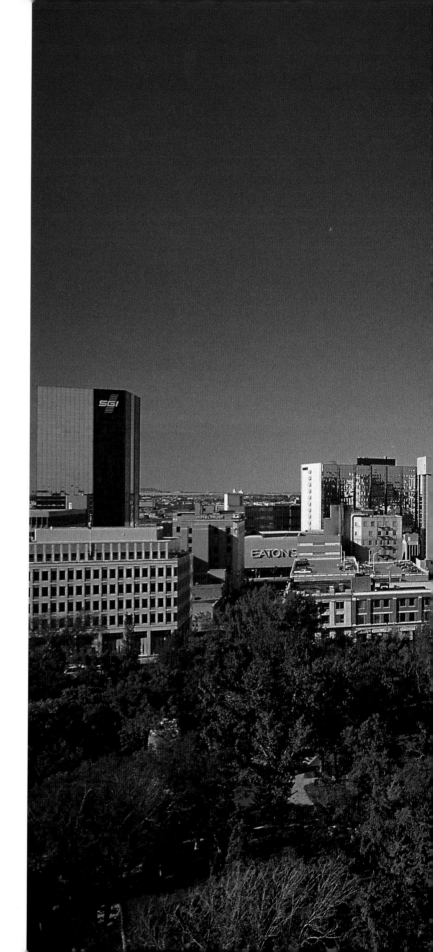

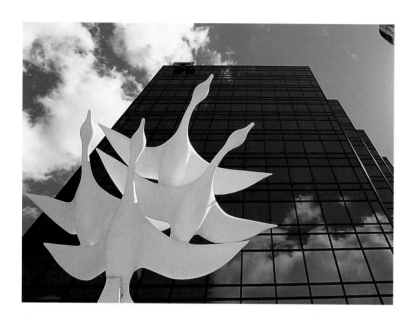

Western Spirit, a sculpture of four Canada geese carved by Dow Reid, stands outside Regina's Canada Trust Building.

In most cities, trees are felled to erect buildings. In Regina, where no trees grow naturally, they are hand-planted around the buildings.

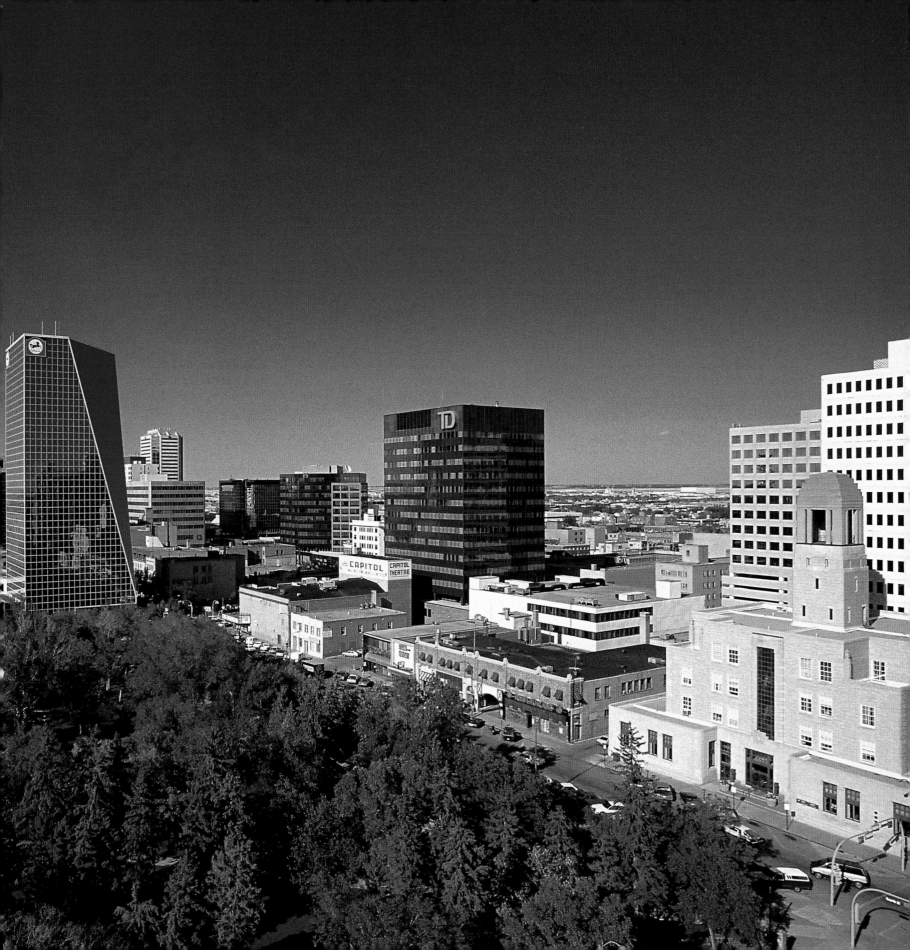

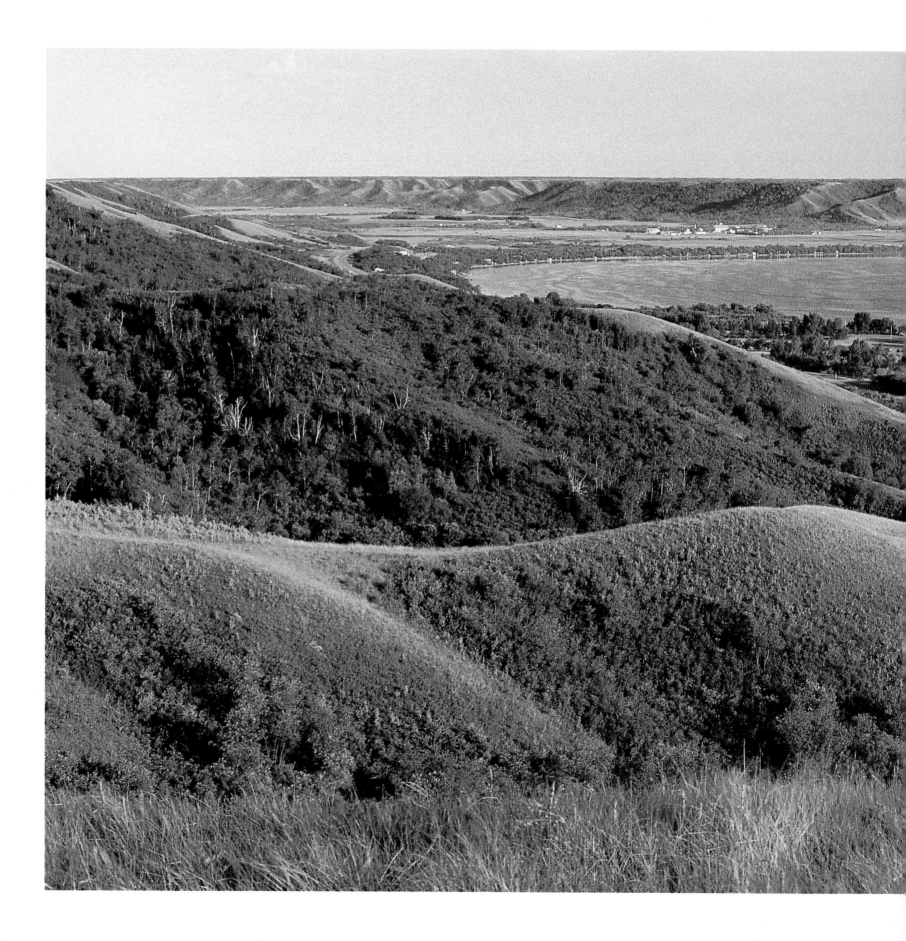

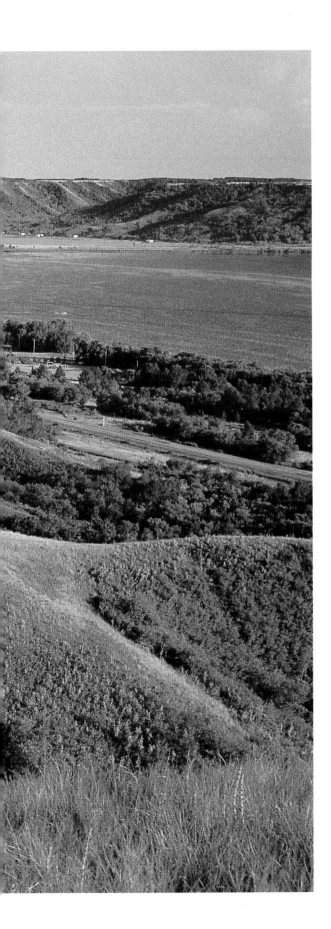

According to First Nations legend, a young man once heard echoes in the Qu'Appelle Valley calling his true love's name. Qu'Appelle means "who calls?"

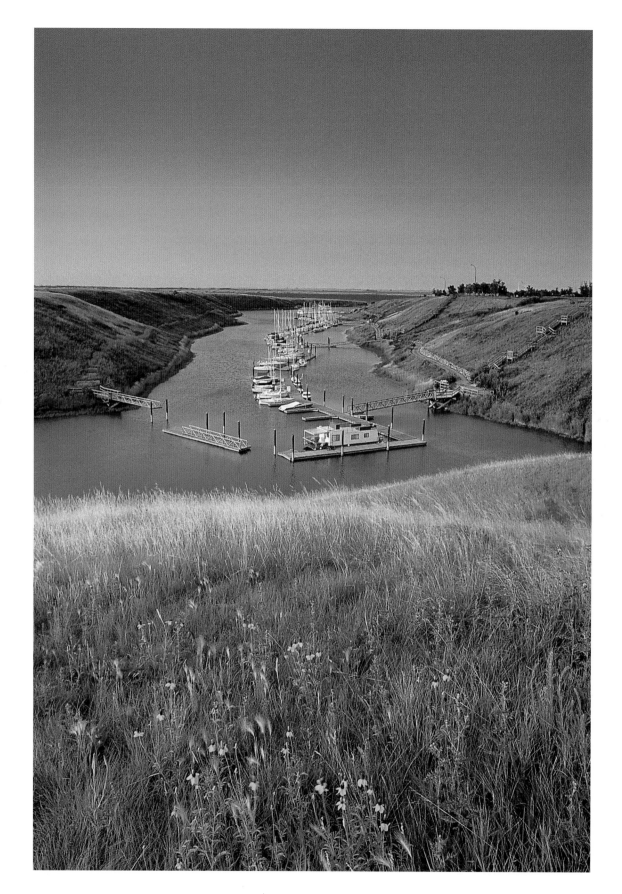

When the Gardiner Dam was built across the South Saskatchewan River in the 1960s, it flooded a huge valley to create this 225-kilometre-long lake. The lake is named for John G. Diefenbaker—"Dief the Chief"—who became prime minister of Canada in 1957.

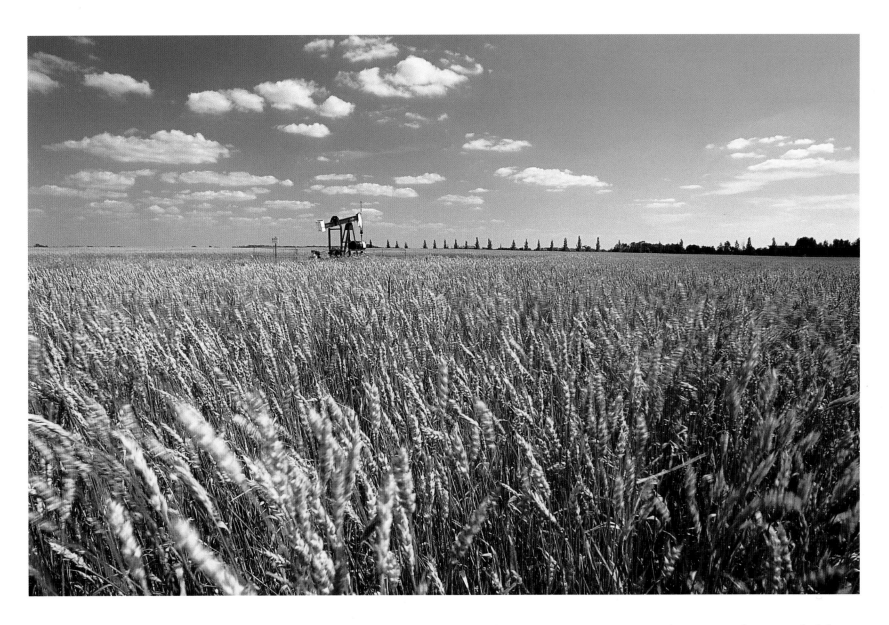

Oil pumps are a common sight among the grain fields of Saskatchewan. Although not nearly as large as it is in neighbouring Alberta, the industry continues to grow.

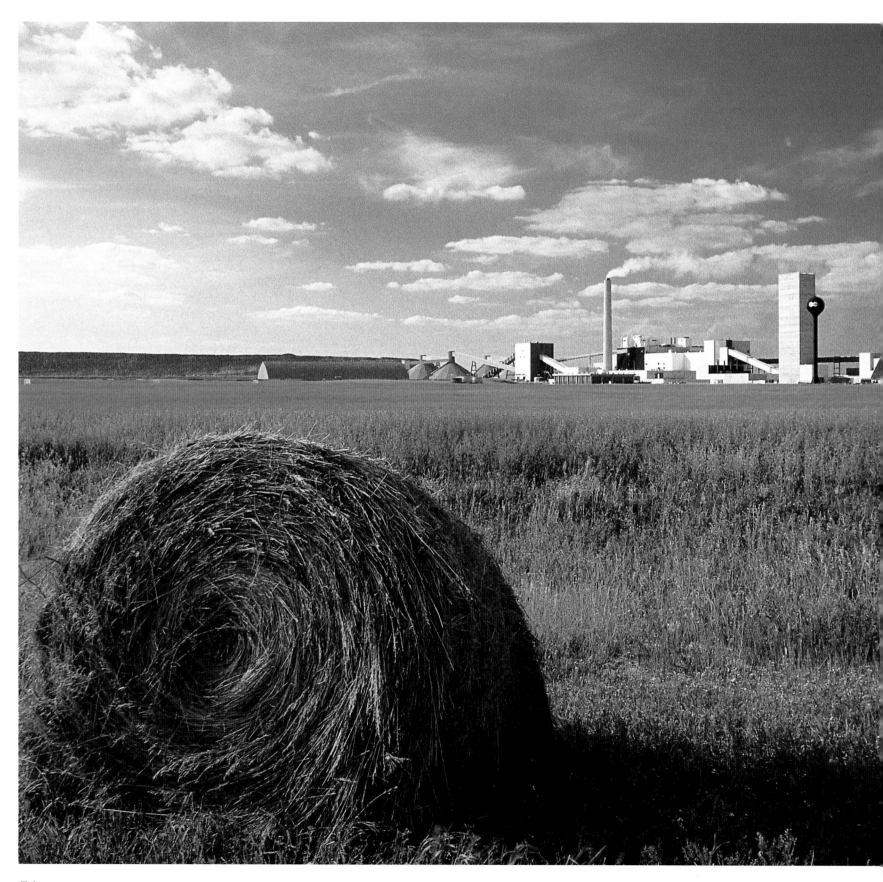

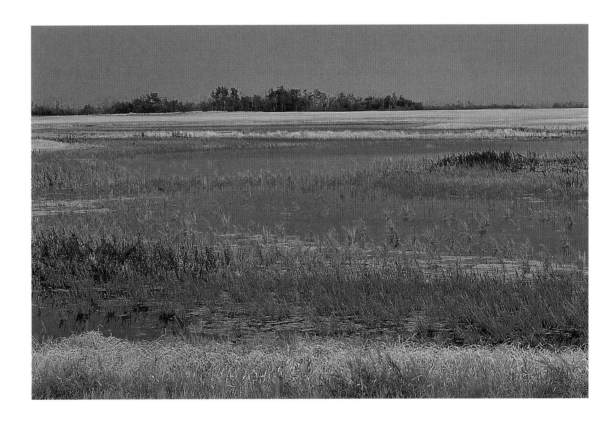

Marshland in southeastern Saskatchewan supports nesting songbirds and offers an important refuge for migrating birds, including snow geese. Snow geese migrate between the Arctic and the Gulf of Mexico.

Saskatchewan holds the world's most valuable potash deposits and Esterhazy is the centre of the province's industry. Potash is used mainly in plant fertilizers.

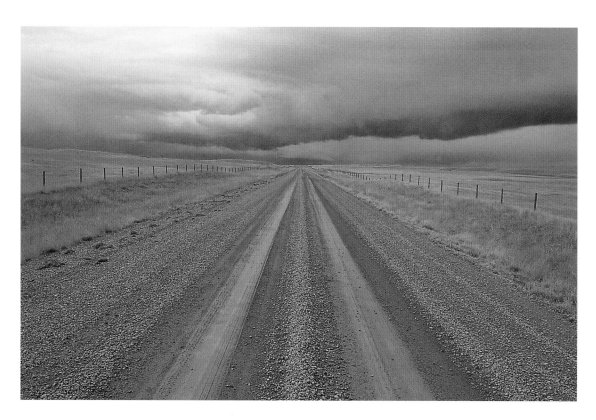

Summer storms, complete with rain, wind,
and hail, are common in Saskatchewan. In 1973
a 290-gram hailstone, the largest in Canadian
history, fell in the town of Cedoux.

Picturesque farmland surrounds Ponteix.
The town was founded by Father Albert
Royer, a Roman Catholic missionary, and
named after his parish in France.

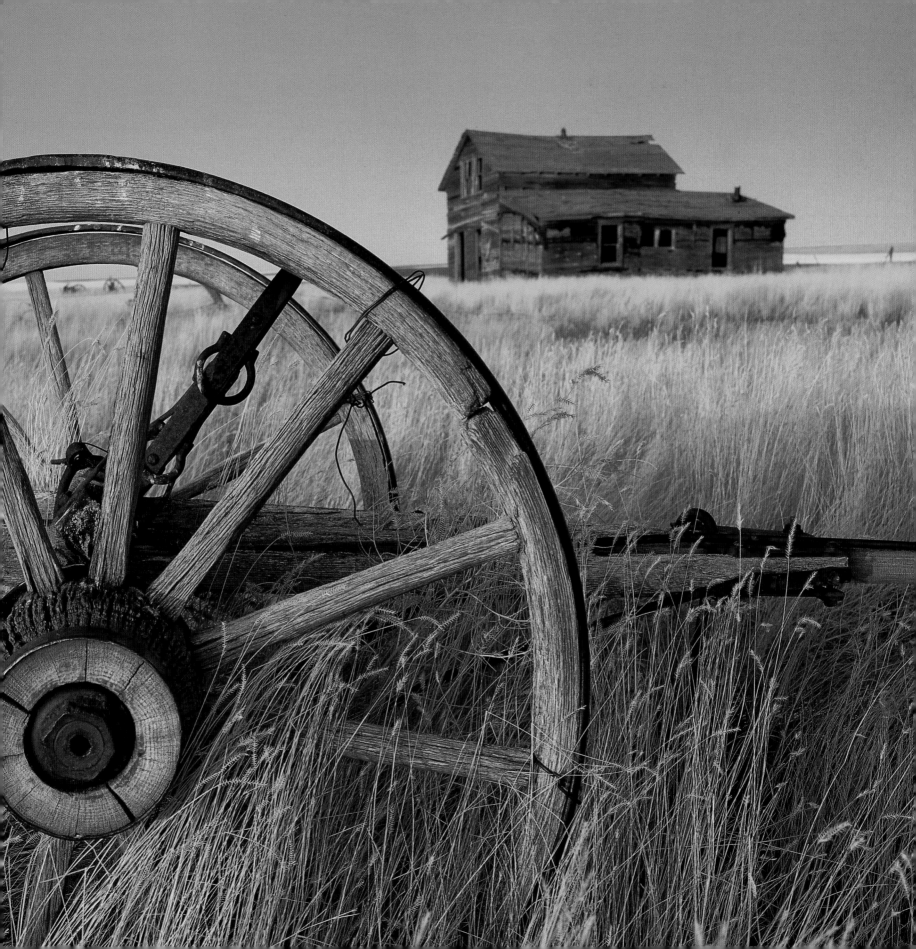

Distinct onion-domed churches mark the influence of Ukrainian Canadians on the prairies. Farmers from the Ukraine were some of Saskatchewan's earliest and most successful settlers.

OVERLEAF –
Saskatoon was founded by members of a Methodist temperance group in 1883. In 1900, just over 100 people lived here. It is now Saskatchewan's largest city, with a population of 200,000.

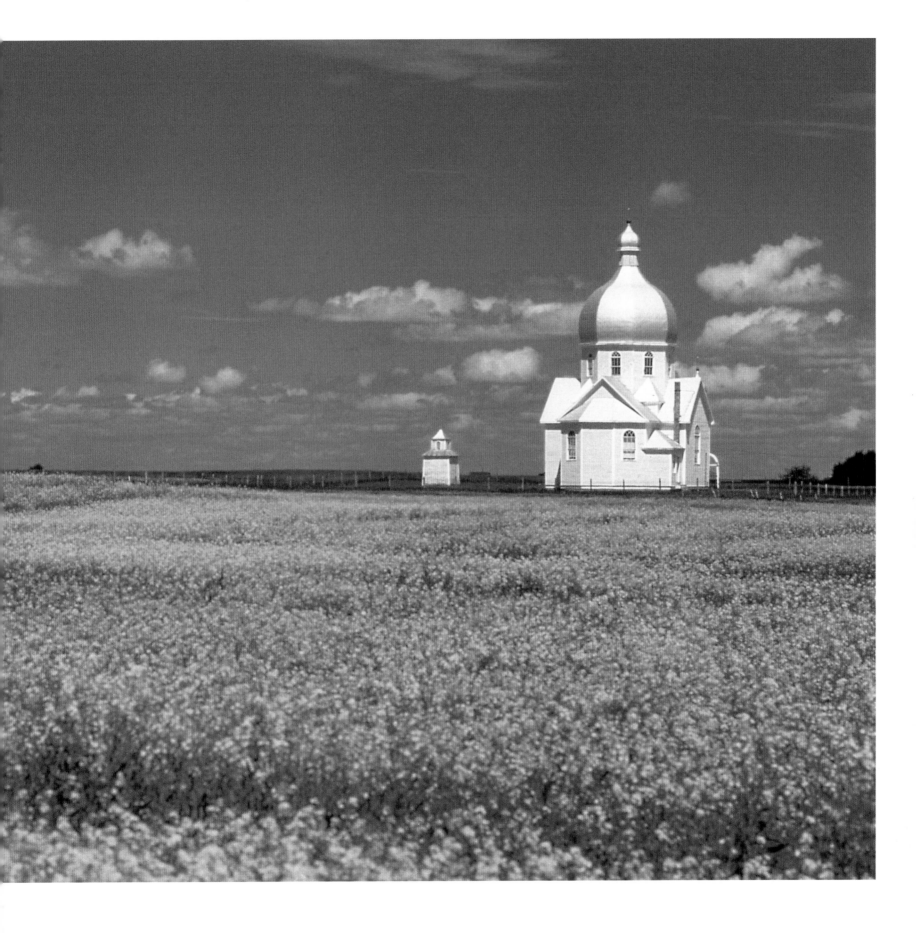

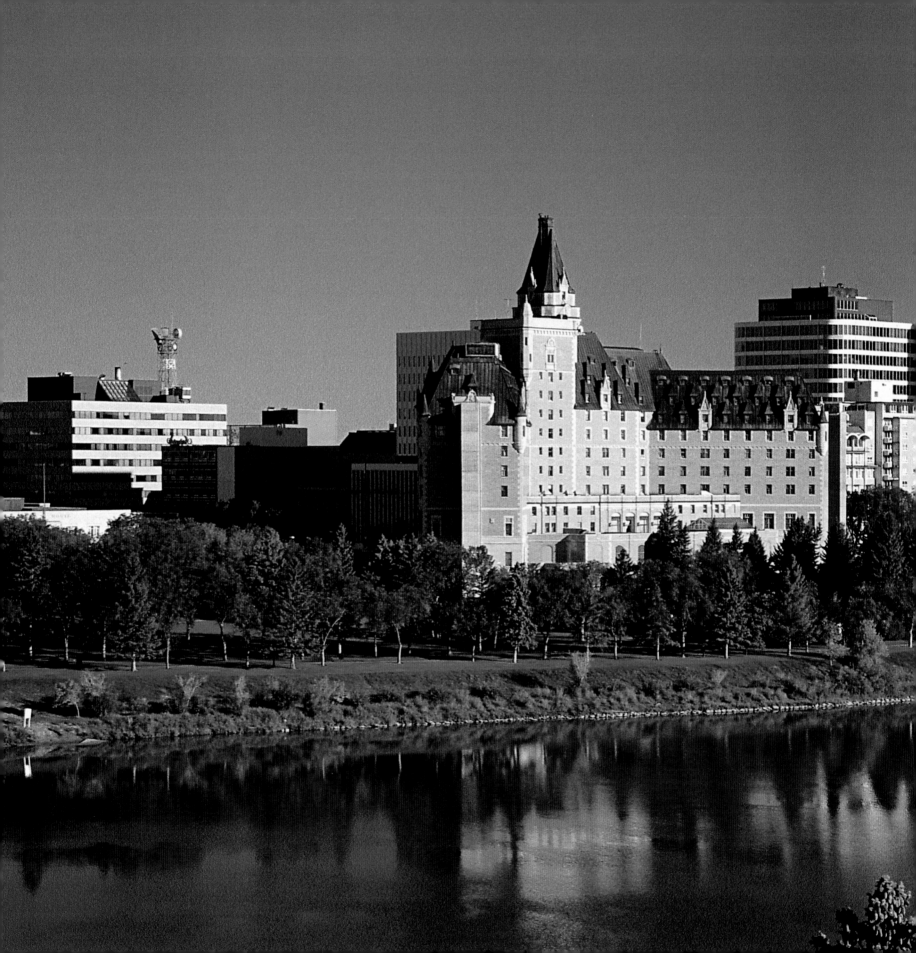

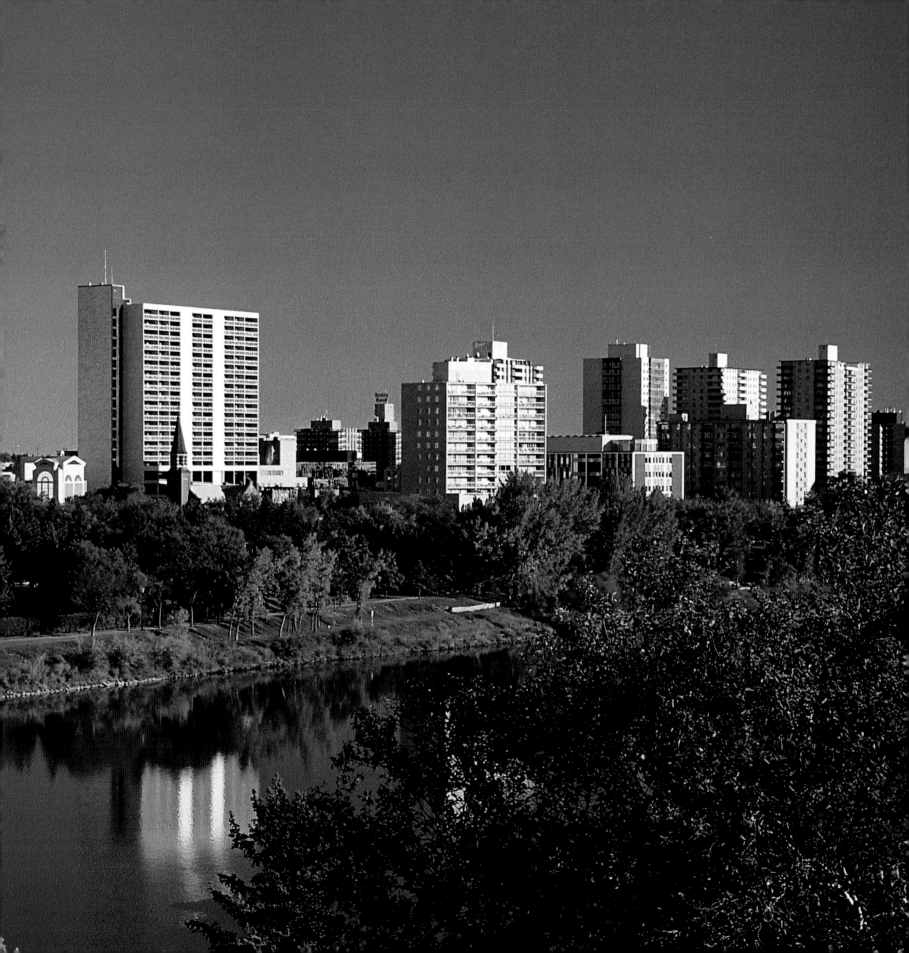

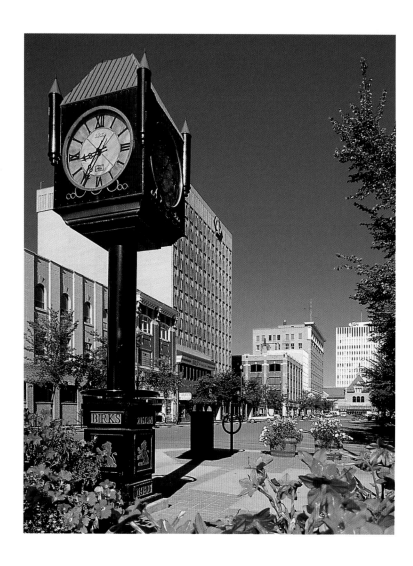

The whistle of the electric clock outside Birks
Jewellers sounds on the hour. Birks donated
the clock to the city of Saskatoon in 1990.

The University of Saskatchewan held its first
classes in 1909, with a total enrollment of 70
students. There are now more than 18,000
people attending Saskatchewan's biggest
post-secondary institution.

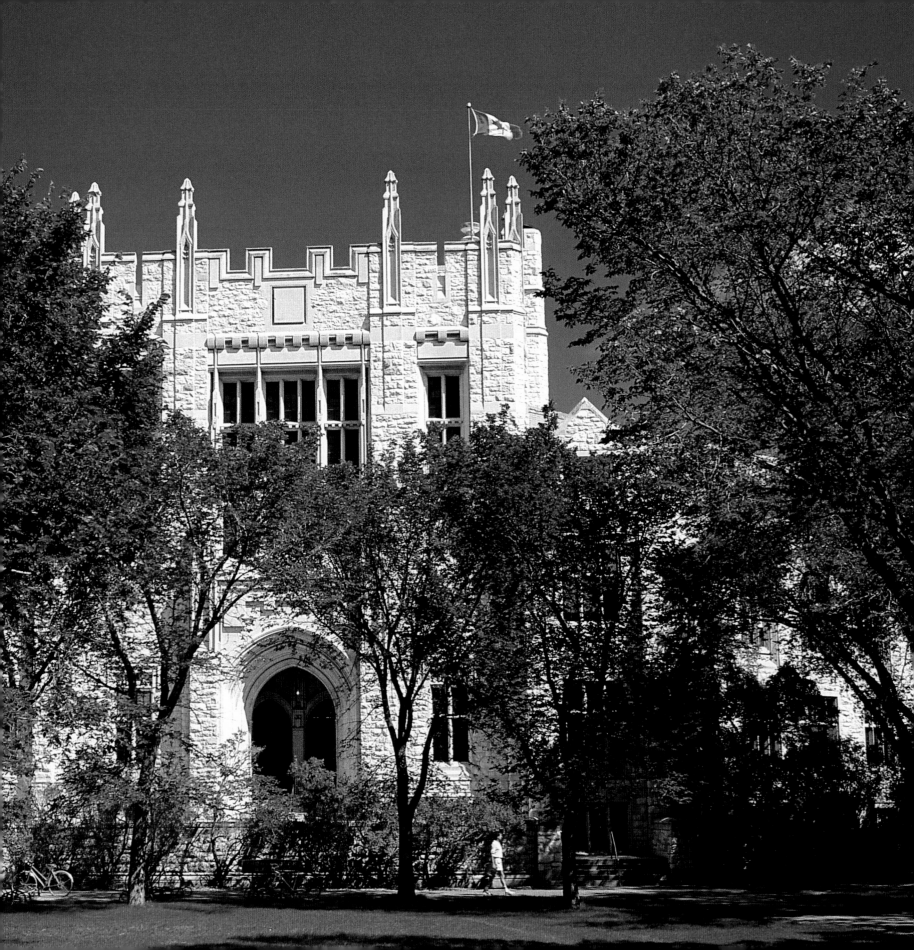

Saskatoon is often called the "City of Bridges," with seven spans across the South Saskatchewan River. Broadway Bridge links the historic shopping area of Broadway Avenue, the city's oldest shopping district, with downtown.

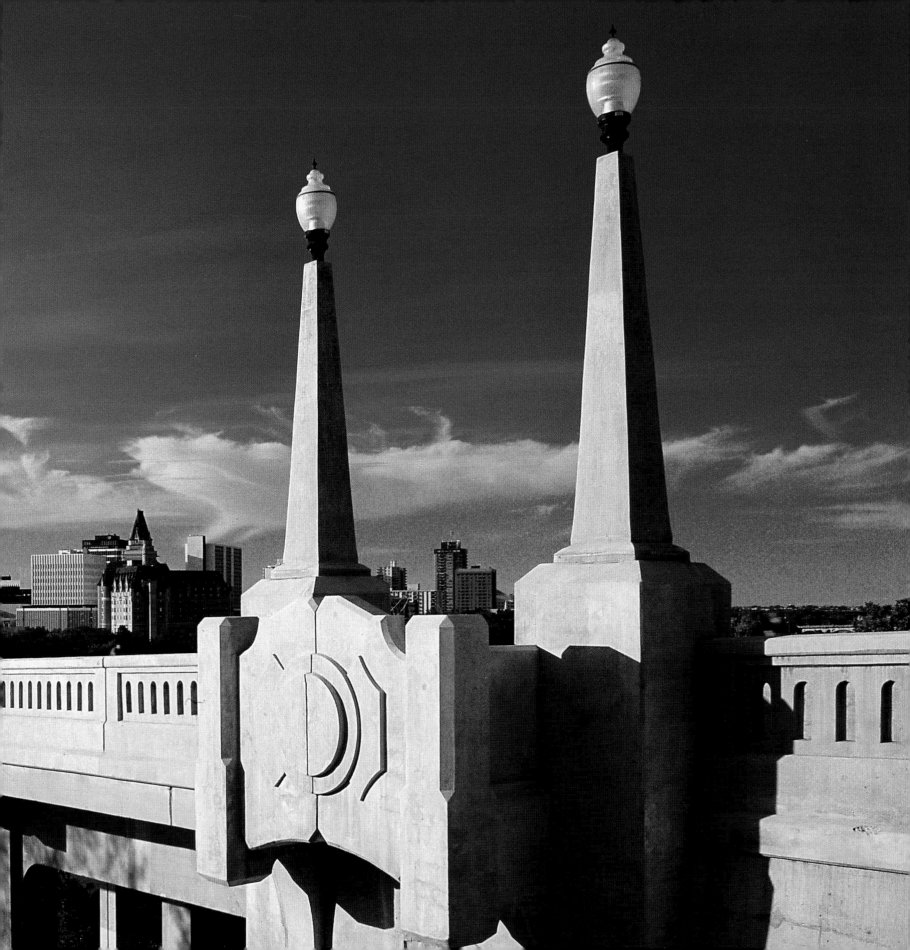

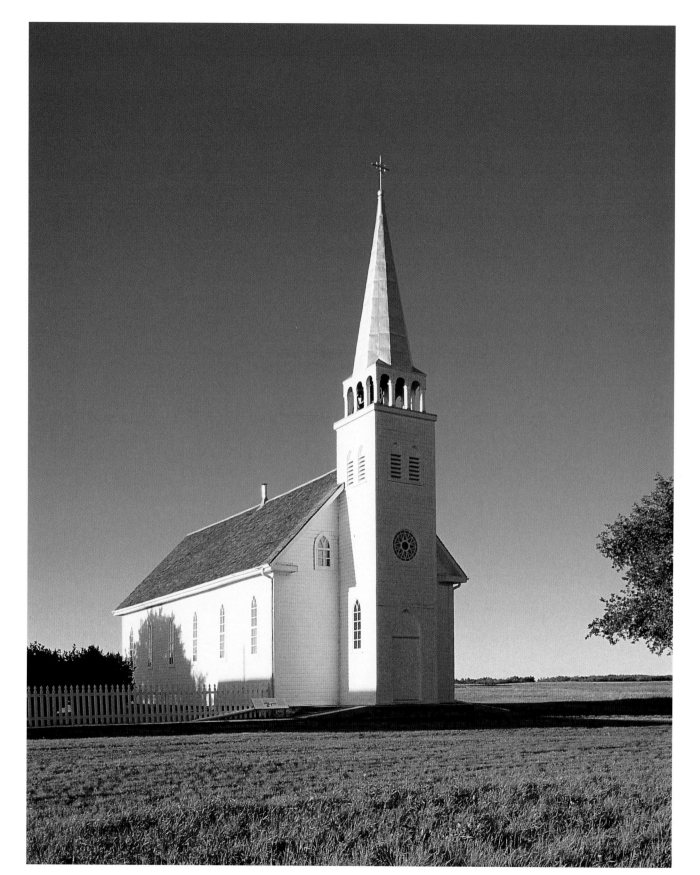

The church and rectory are all that remain of the Metis village where Louis Riel and his followers were defeated in May 1885. Batoche National Historical Site commemorates the doomed rebellion and the struggle of the Metis people.

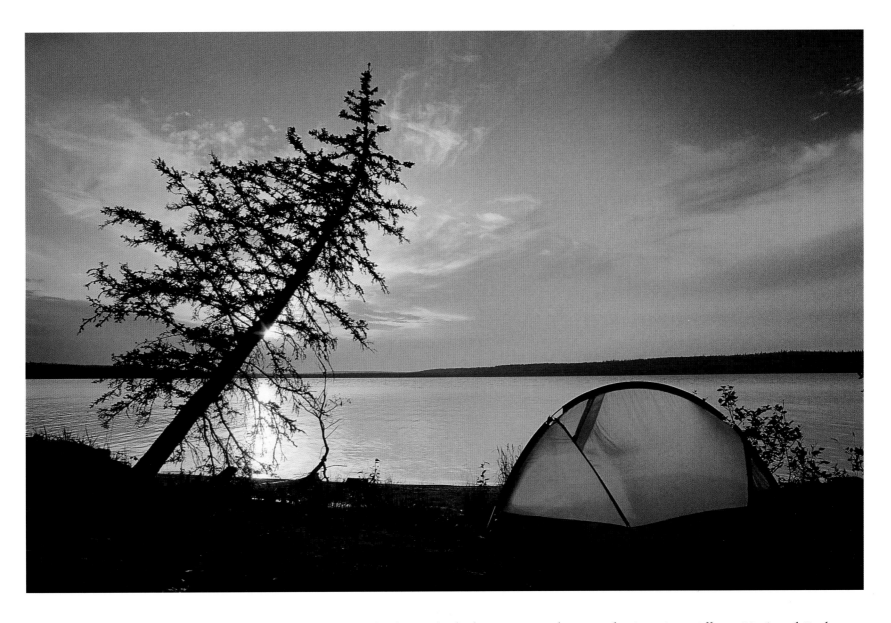

Campers find a secluded site on Waskesiu Lake in Prince Albert National Park. One of Saskatchewan's most popular hiking and camping destinations, the park's varied terrain includes marshland, lakeshore, and meadows.

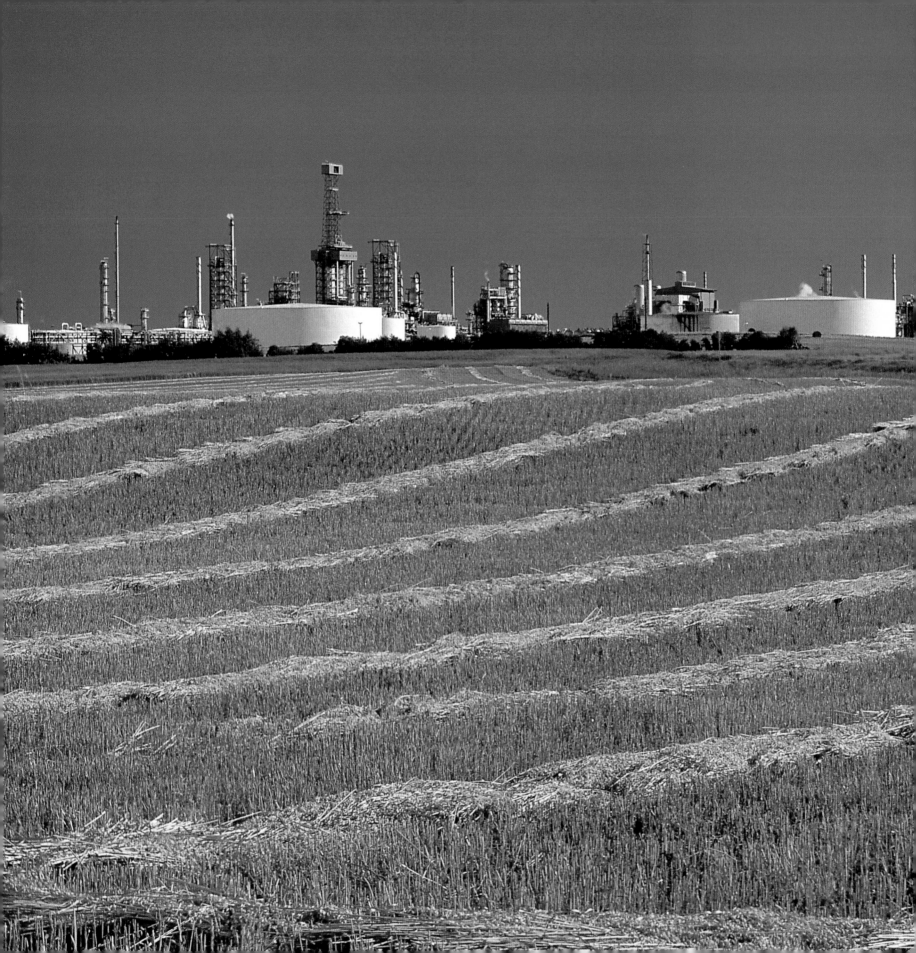

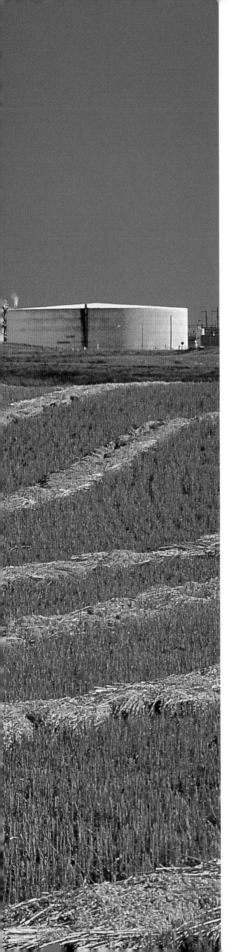

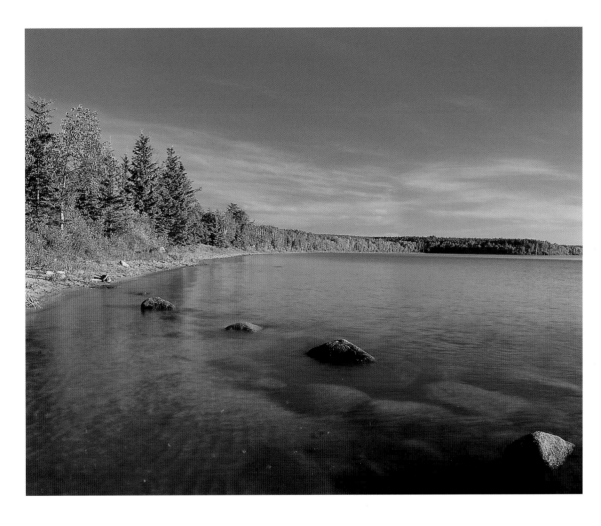

Cold Lake extends across the Alberta-Saskatchewan border. Its eastern shore is protected by Saskatchewan's Meadow Lake Provincial Park, a 120-kilometre-long reserve encompassing a string of smaller lakes.

Lloydminster, a city bisected by the Alberta-Saskatchewan border, was settled by British immigrants in 1903. It began as an agricultural centre but has grown with the development of heavy oil resources.

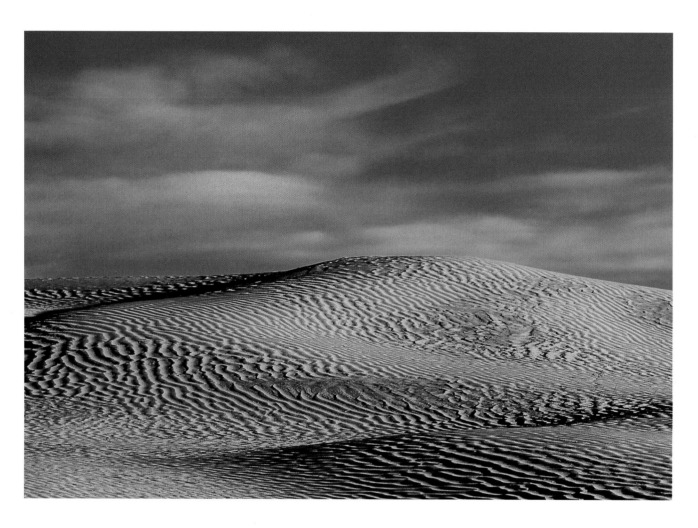

The Great Sand Hills of Saskatchewan, swept bare
by the wind, span 1,900 square kilometres between
Maple Creek, Leader, and Webb. Deer, grouse,
coyotes, and owls inhabit the dunes.

In the 1690s, Hudson's Bay Company employee Henry
Kelsey was the first European to explore Saskatchewan.
Today, much of the province remains sparsely popu-
lated, a web of grasslands and rivers.

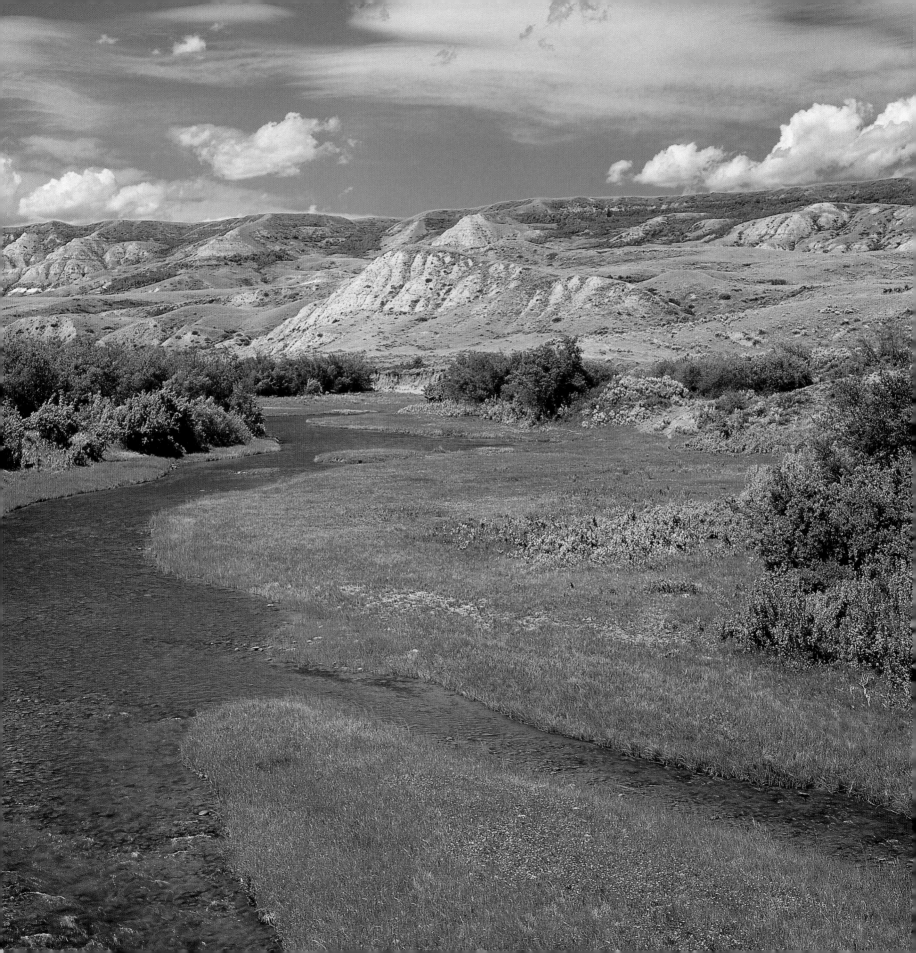

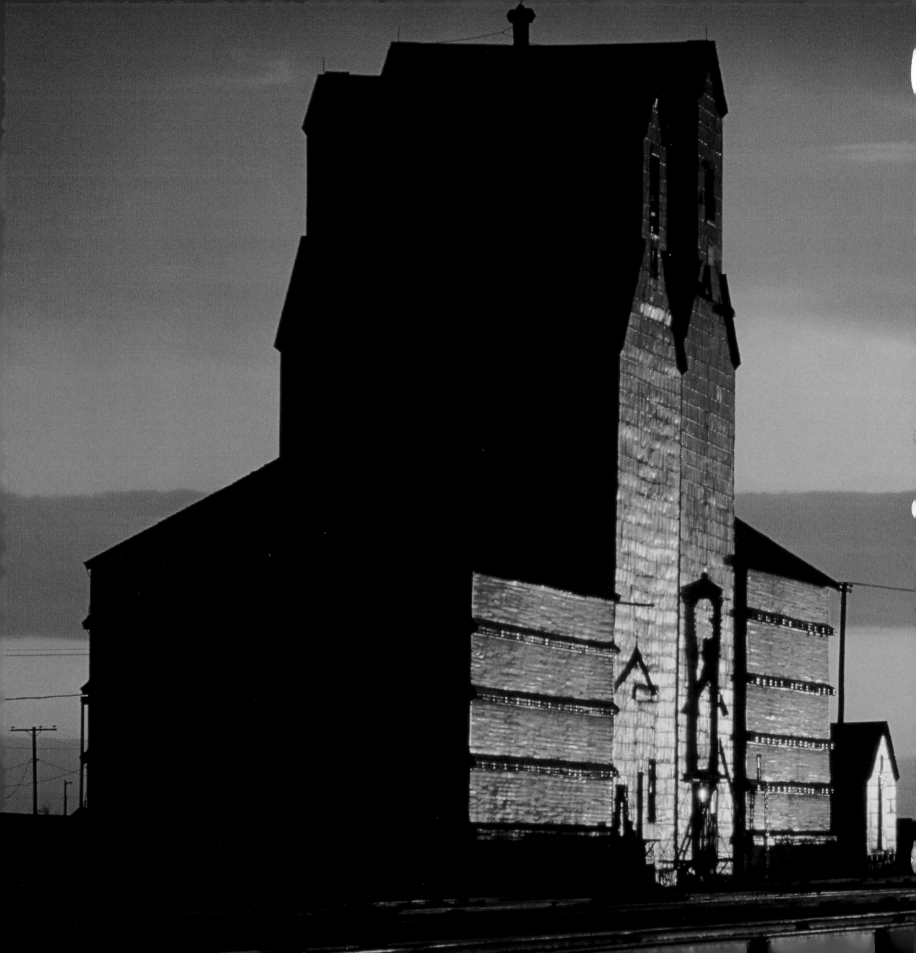

Farmers deliver their grain to elevators such as this one in Maple Creek. From there, trains carry it to port cities—often to Thunder Bay, Ontario—where it is loaded onto ships for export around the world.

73

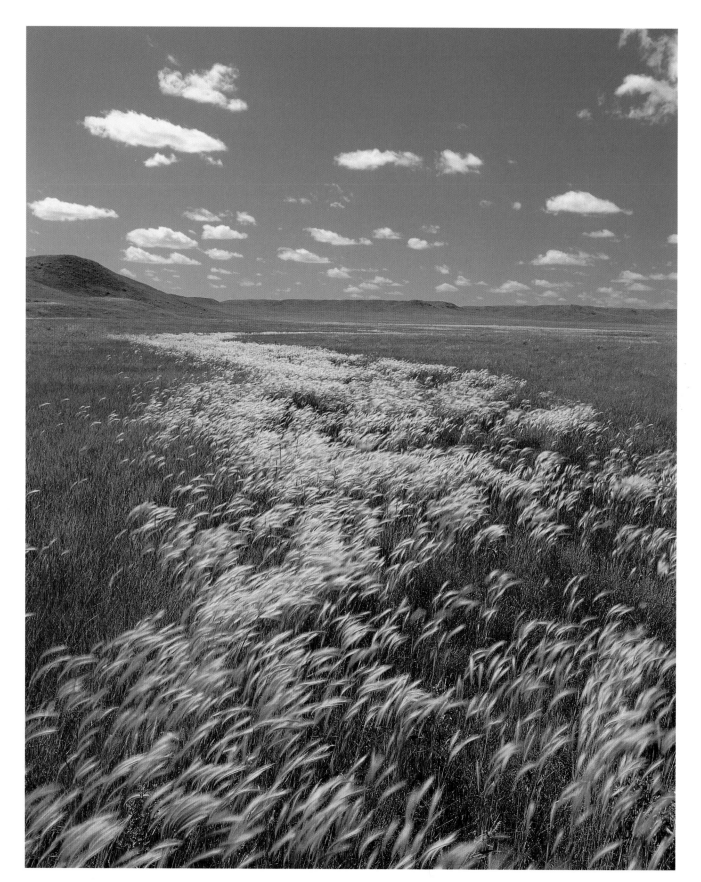

Grasslands National
Park in southwestern
Saskatchewan supports
about 50 grass species.
Left undisturbed, these
grasses blanket the
soil and protect it
from erosion.

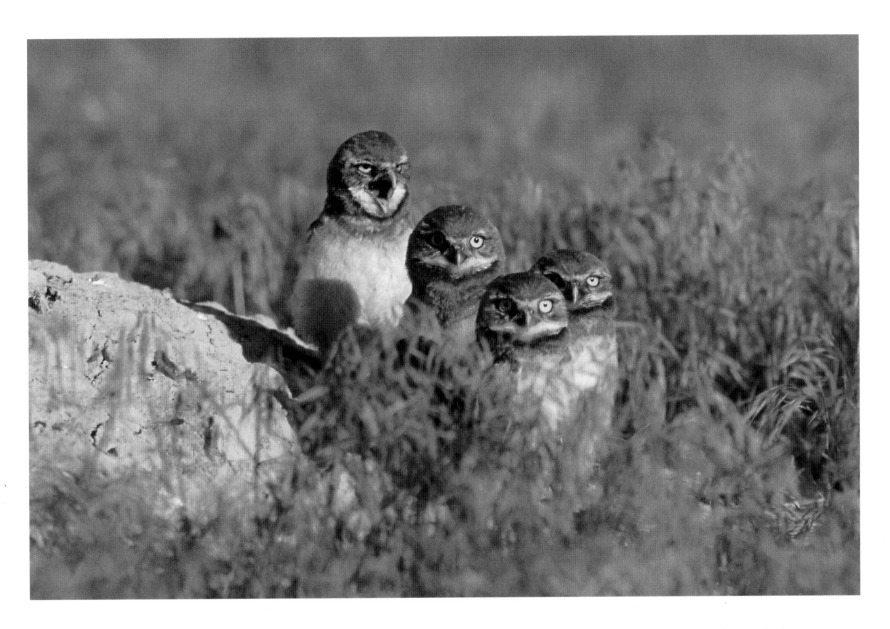

Burrowing owls live in the short-grass prairie and nest in burrows dug by mammals. They usually hunt near dusk and dawn but can sometimes be seen on summer days, when they must hunt more often to feed their young.

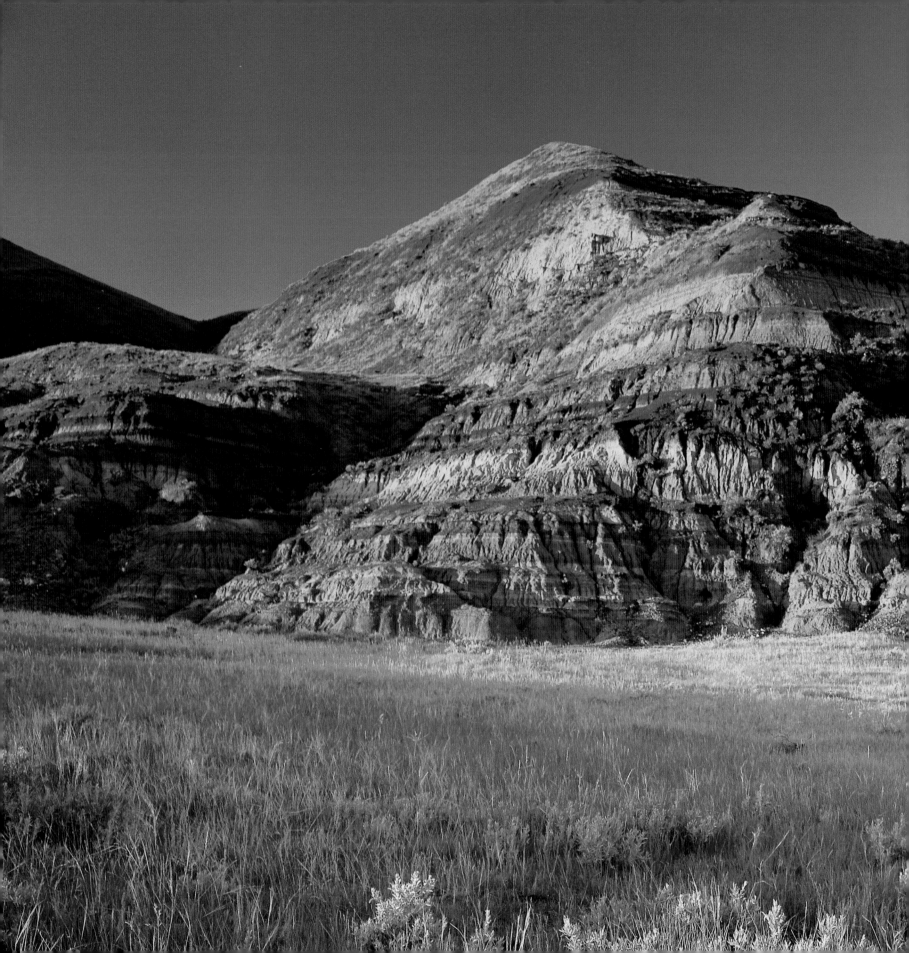

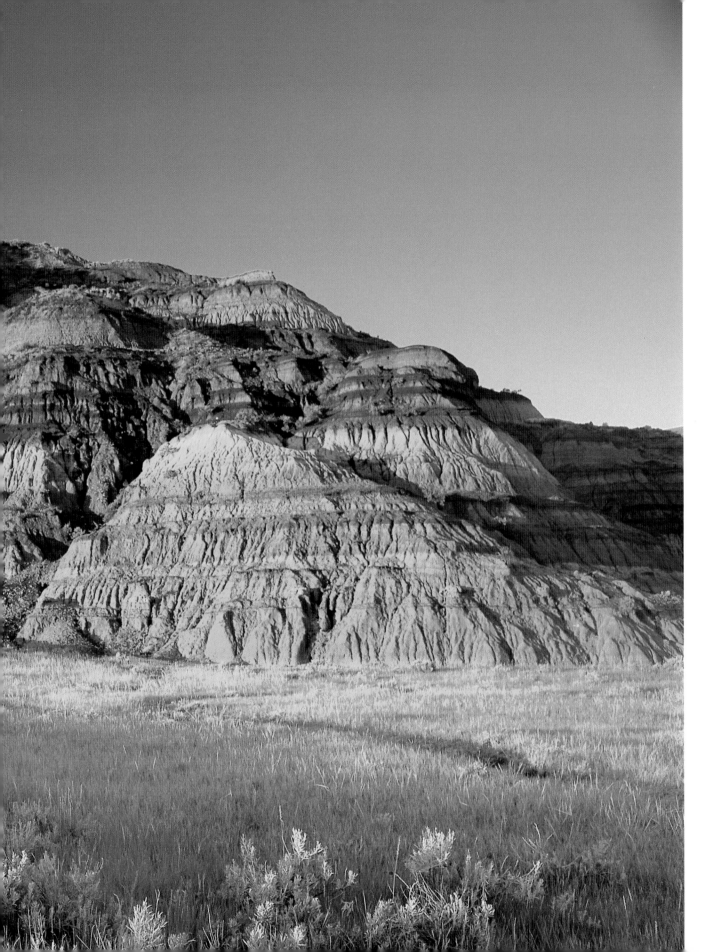

Caves in Big Muddy
Badlands were once
the northern terminus
of Butch Cassidy's
Outlaw Trail, a series
of hideouts and
supply posts stretching
south to Mexico. Other
intriguing characters
of badlands history
include infamous
horse thief Dutch
Henry and First
Nations Chief Sitting
Bull, who sought
refuge here after
defeating General
Custer in Montana.

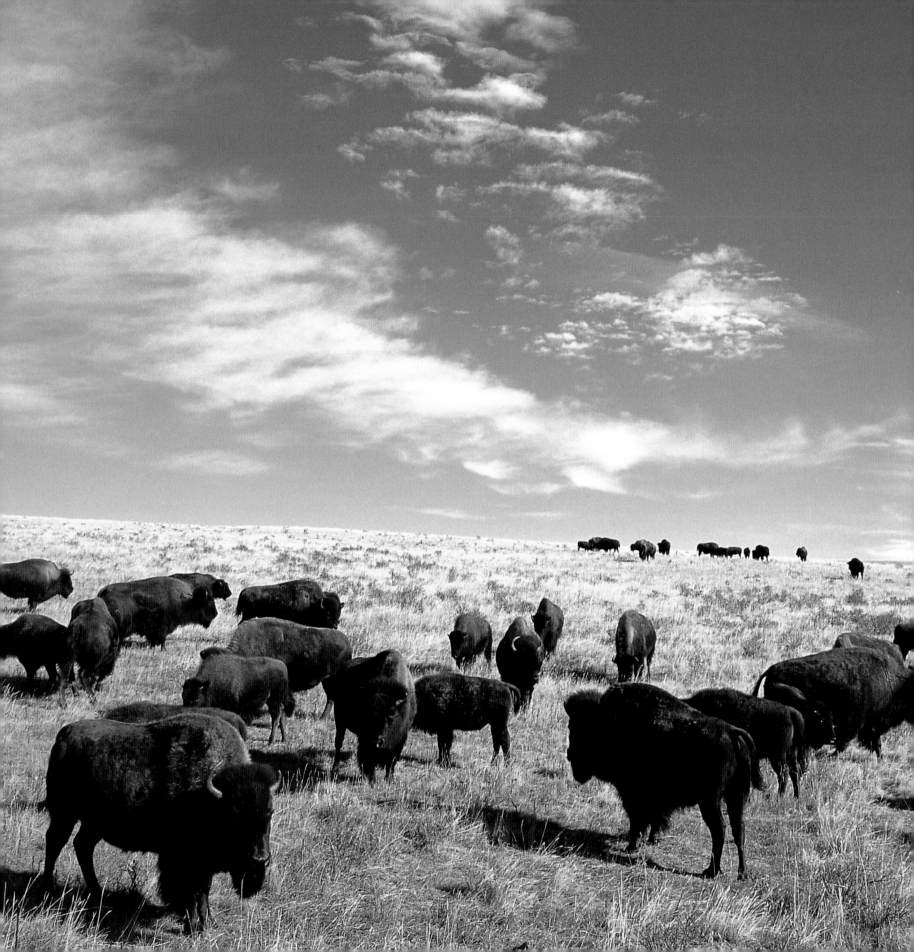

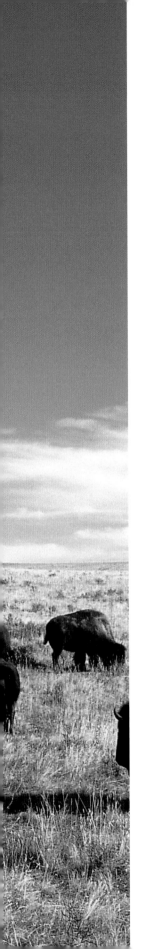

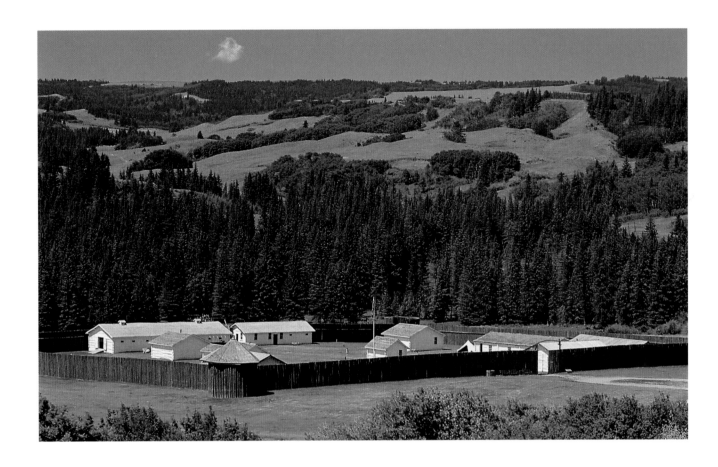

Fort Walsh was established by the North-West Mounted Police in response to unrestricted whiskey and fur trading in the late 1800s. In 1873, wolf hunters killed 20 natives near here in what is now known as the Cypress Hills Massacre.

The bison is the largest land animal in North America. There were once about 60 million bisons in North America. They were hunted almost to extinction, but government protection in the late nineteenth century saved them. There are now about 200,000.

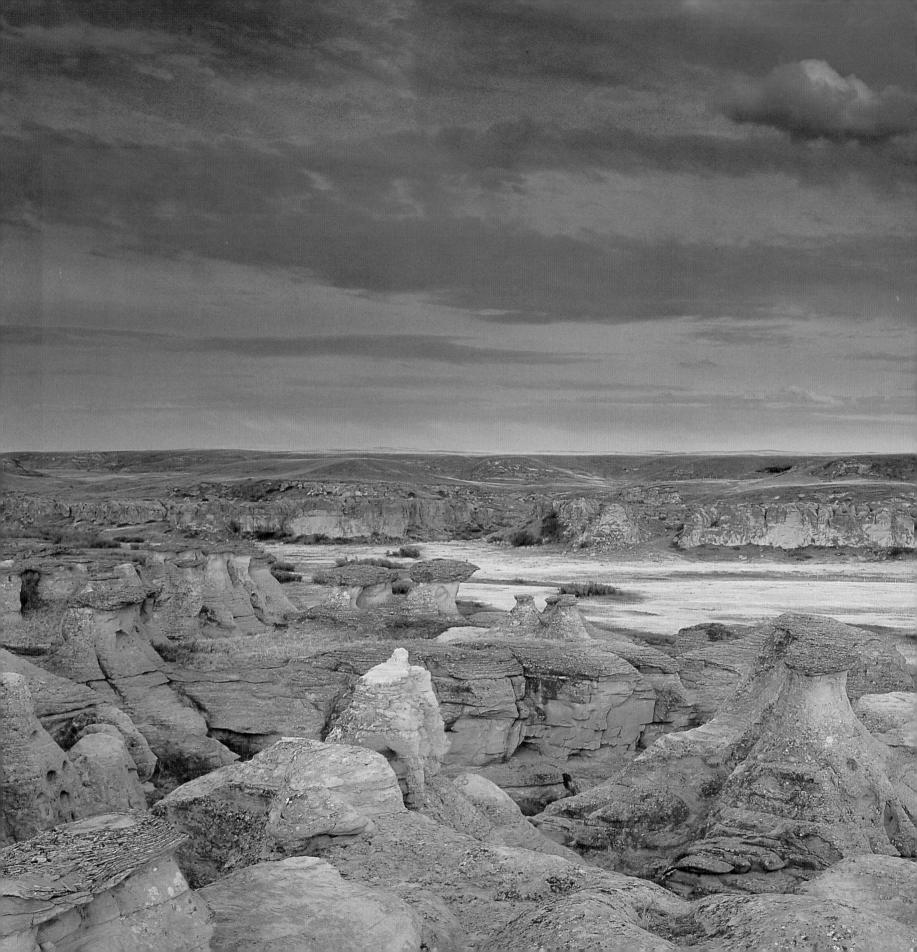

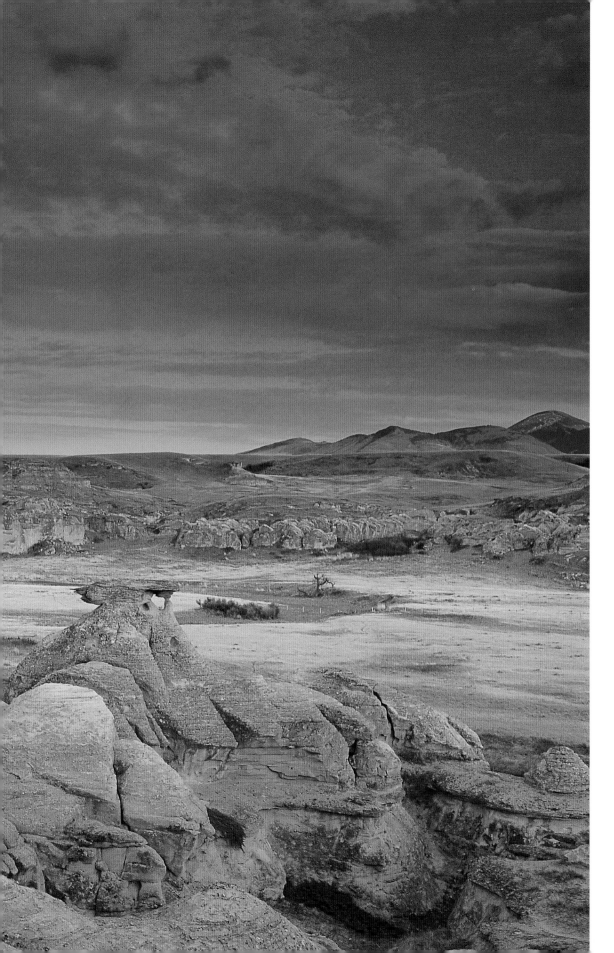

The hoodoos at Writing-on-Stone Provincial Park in Alberta were formed by erosion. A hard cap tops each hoodoo, protecting it from the wind and rain that abraded the surrounding stone. Eventually, the caps are also worn away and the hoodoos diminish in size.

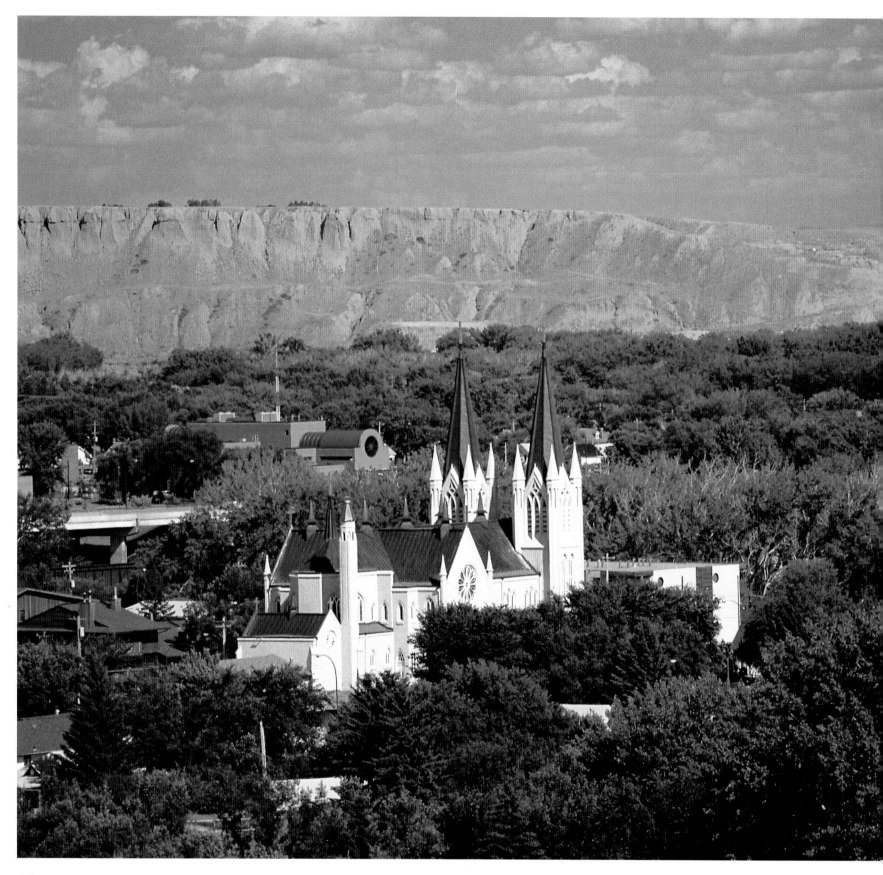

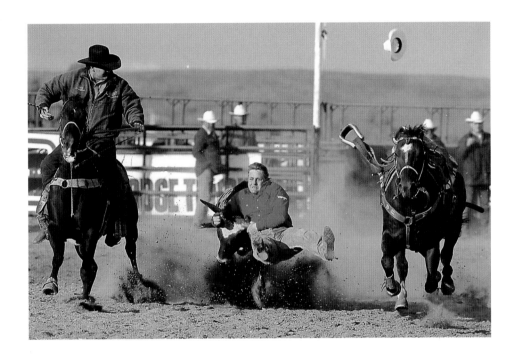

At the heart of one of Alberta's prime ranching areas, Pincher Creek has a long tradition of cowboys, cattle driving, and steer wrestling.

This picturesque view of Medicine Hat doesn't reveal what lies below the town. Vast underground reserves of natural gas caused Rudyard Kipling to proclaim that Medicine Hat had "all hell for a basement."

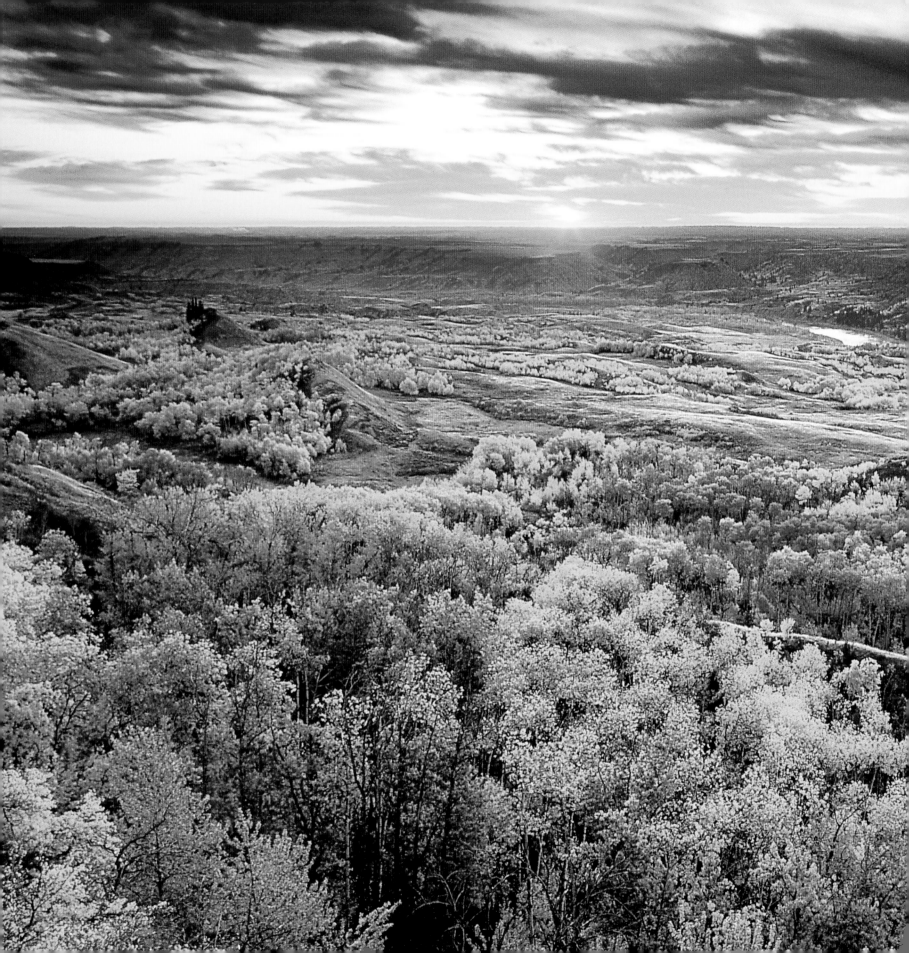

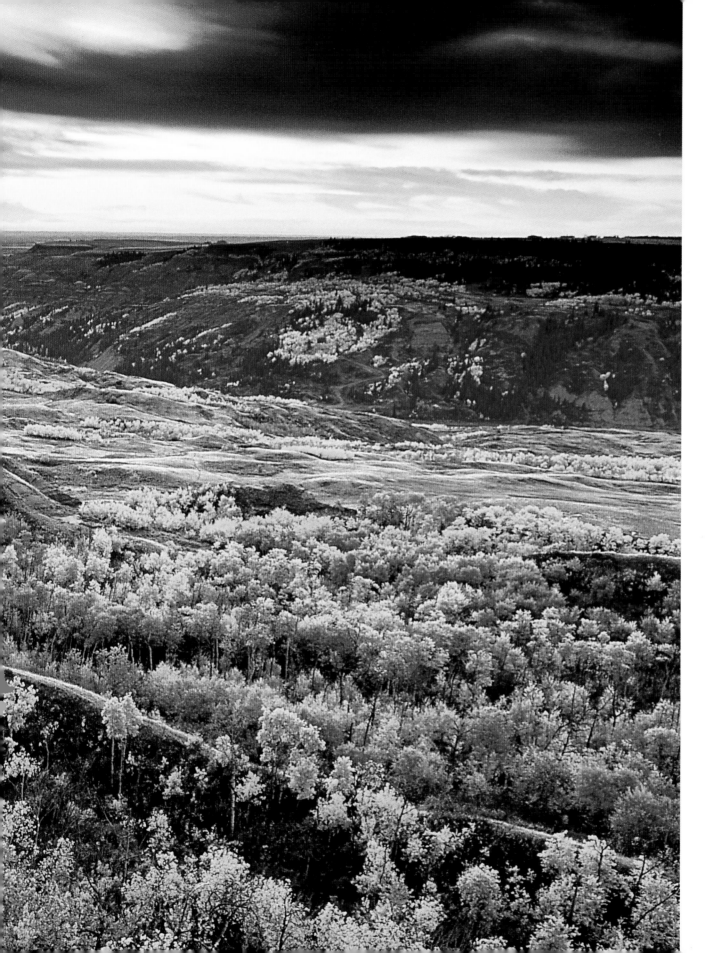

Buffalo jumps, such as the one at Dry Island Buffalo Jump Provincial Park in Alberta, are almost invisible from ground level. Dry Island's high plateau was never surrounded by water—thus its unusual name.

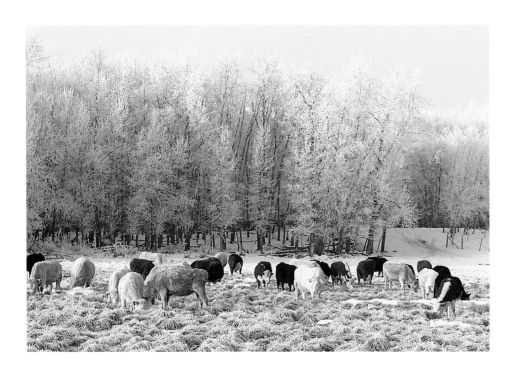

Stony Plain, west of Edmonton, has been an agricultural community since the turn of the century.

When the Calgary Flames are in town, spectators pack the Olympic Saddledome. Built for the 1988 Winter Olympics, the distinctive Saddledome seats 20,000.

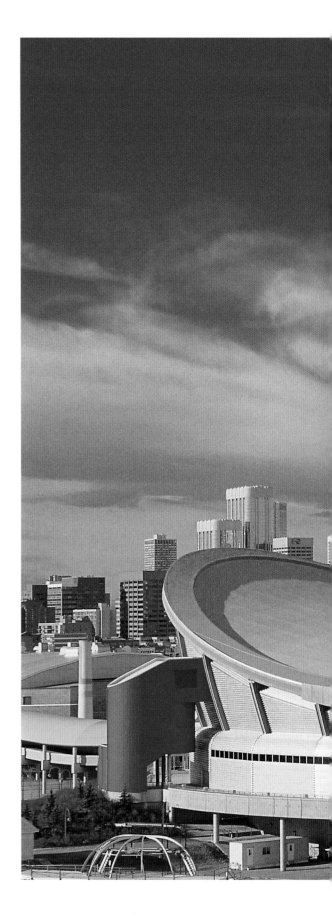

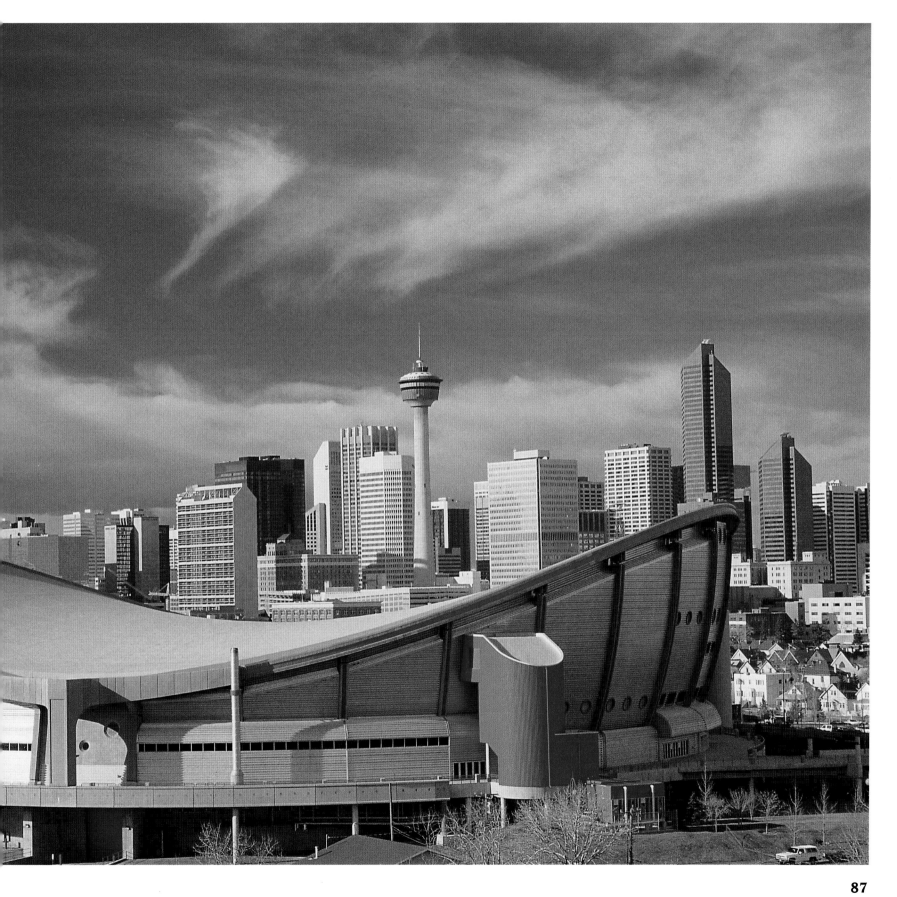

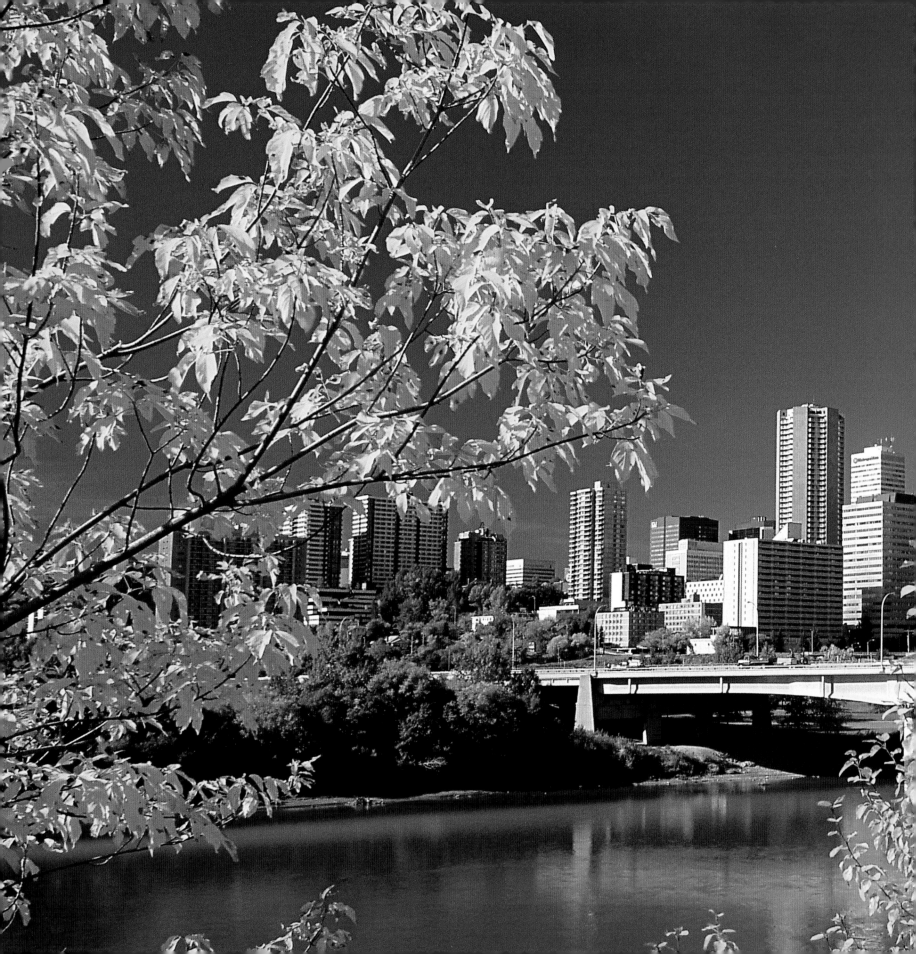

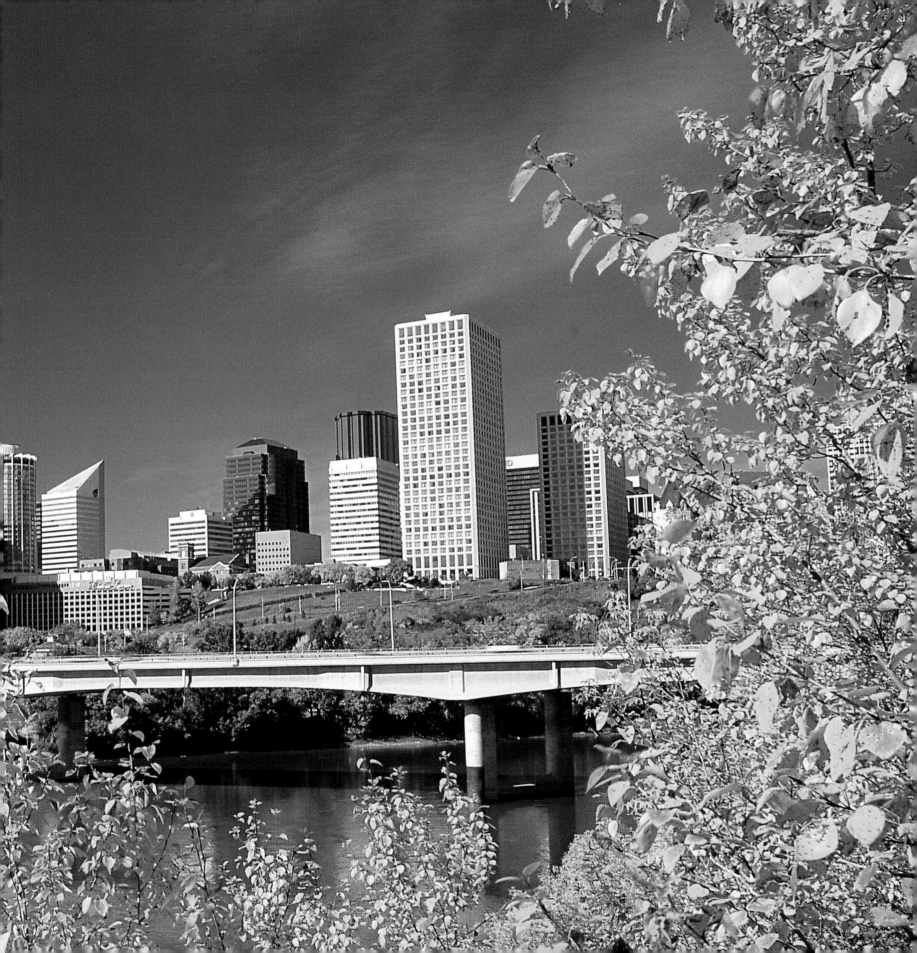

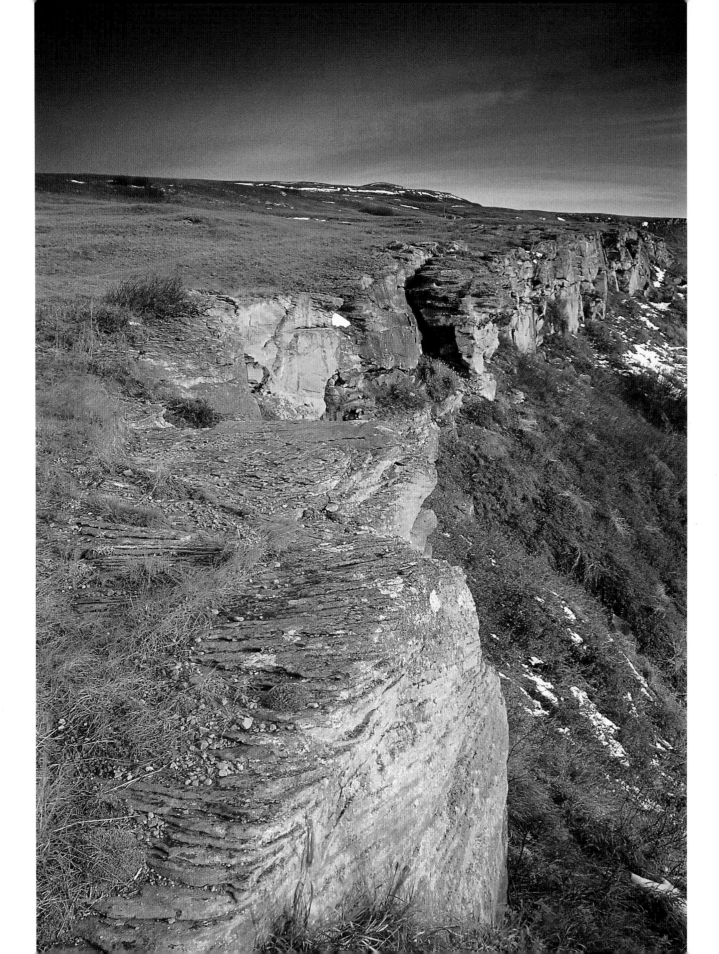

Scientists estimate that native hunters began using Head-Smashed-In Buffalo Jump 5700 years ago; the bones at the base are piled 10 metres deep. Today, First Nations staff are on hand at the interpretive centre to guide visitors through the hunt and the area's history.

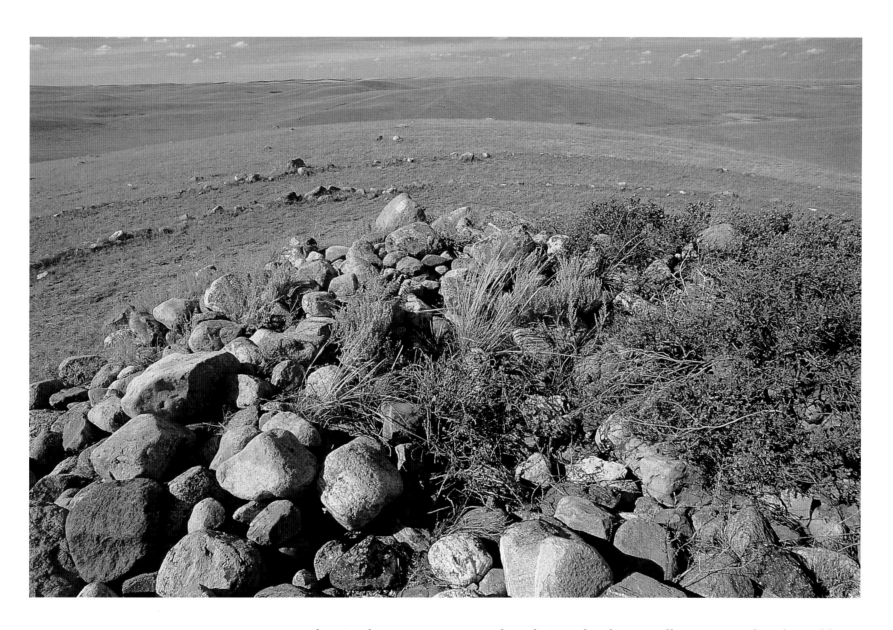

The circular stone patterns of medicine wheels are still constructed and used by the Blackfoot First Nation. Traditionally, the sites have been used for spiritual rites and death ceremonies.

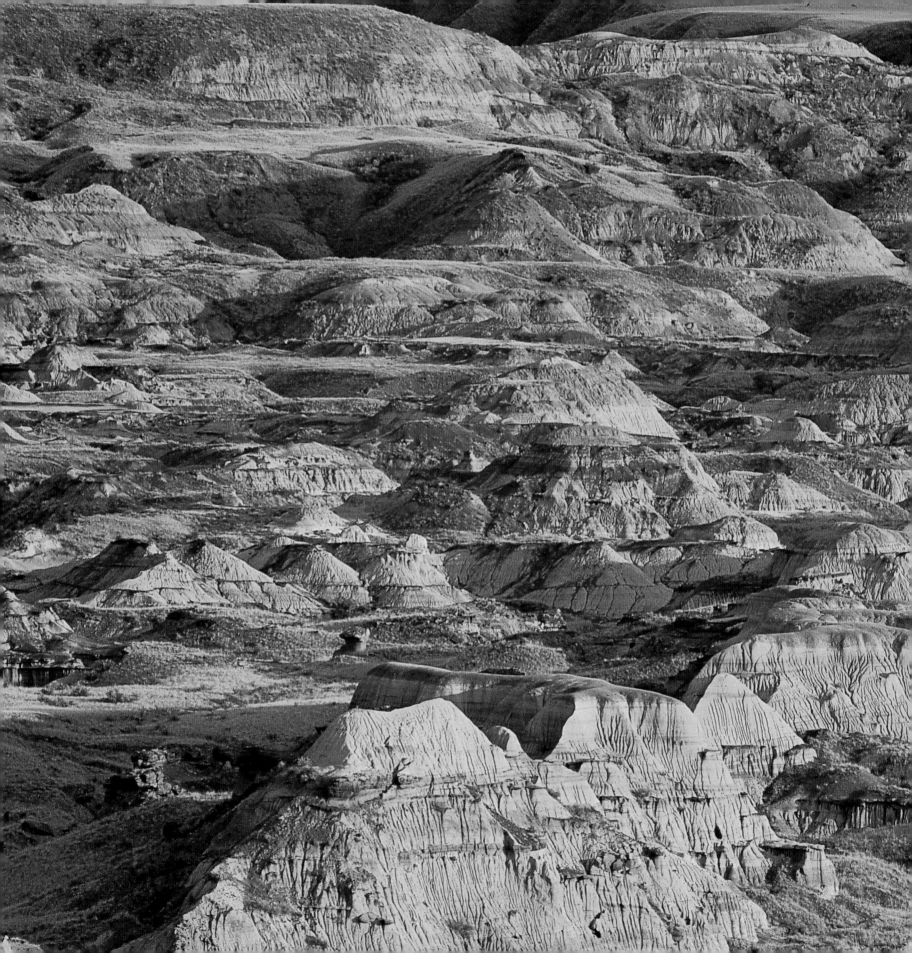

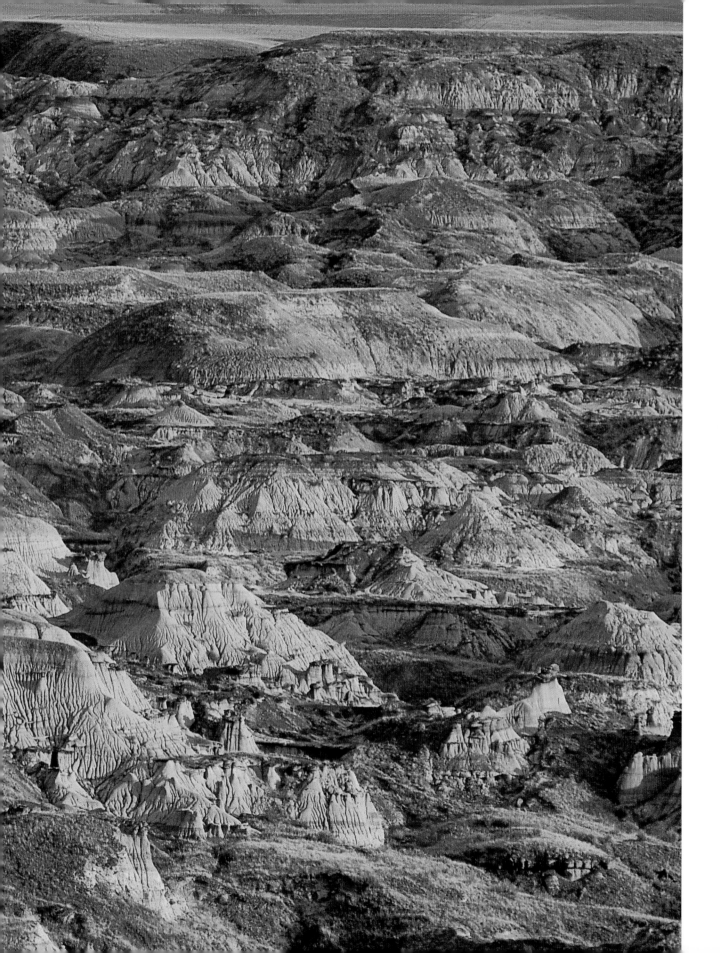

Dinosaurs roamed these badlands 75 million years ago. Archaeologists have unearthed the bones of more than 30 species—17 percent of the world's known dinosaur species—at Dinosaur Provincial Park. The area was much wetter in ancient times; the dinosaur skeletons share the land with crocodile and clam fossils.

OVERLEAF –
A lone canoeist enjoys the serenity of Astotin Lake in Elk Island National Park. The government established the park in 1913 to protect elk from overhunting.

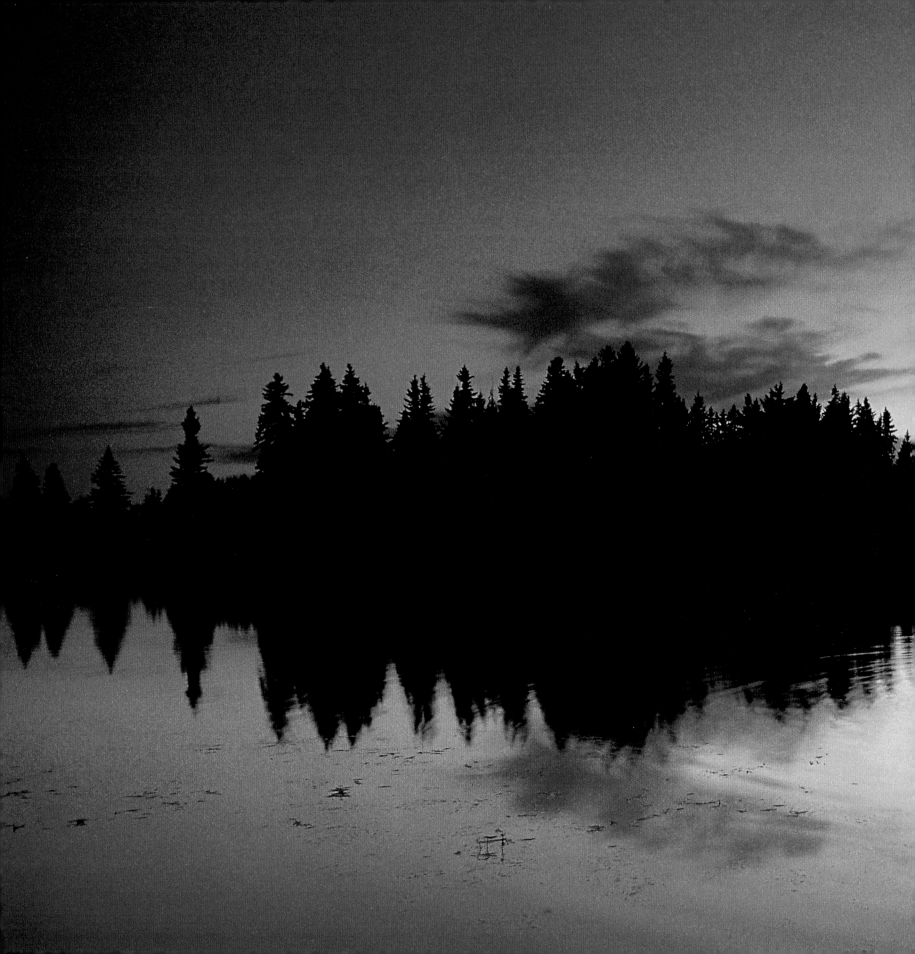

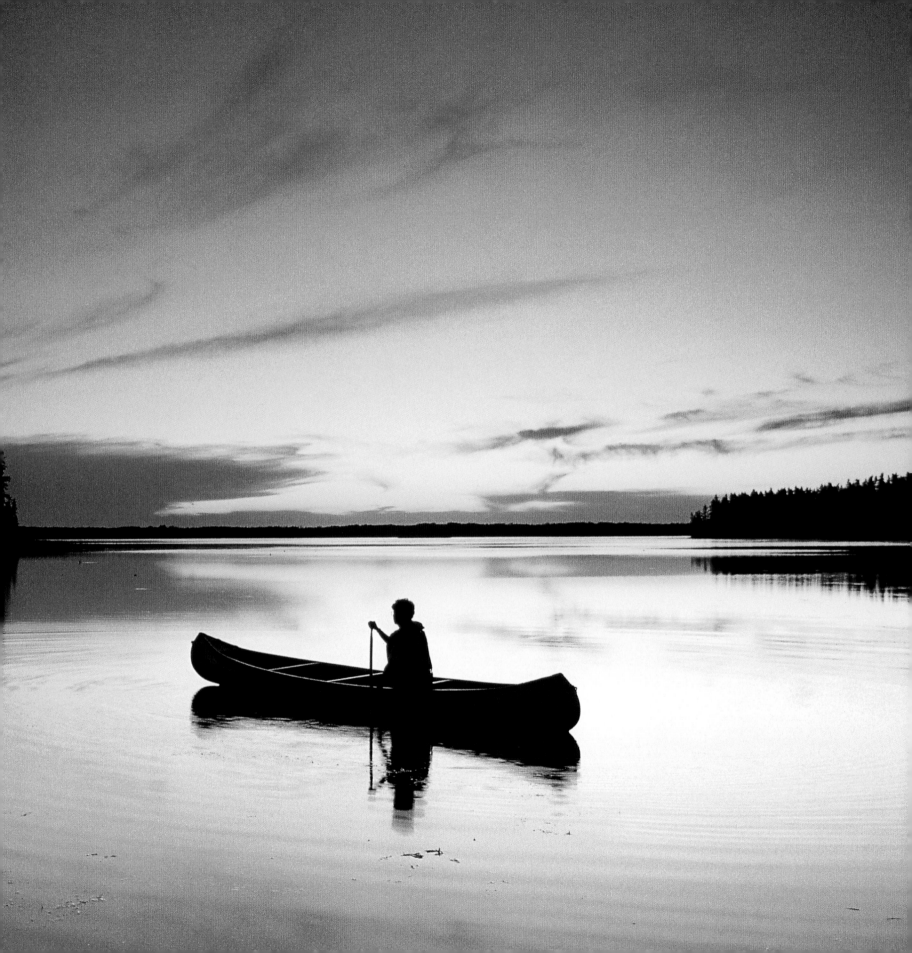

Photo Credits